The Portrait Photographer's Lighting Style Guide

Published in the United States by Amphoto Books, an imprint of the Crown Publishing Group, a division of Random House, Inc, New York.

www.crownpublishing.com
www.amphotobooks.com

AMPHOTO BOOKS and the Amphoto Books logo are trademarks of Random House, Inc.

Library of Congress Control Number: 2010924467

ISBN: 978-0-8174-0005-7

10 9 8 7 6 5 4 3 2 1

First Amphoto Books Edition

Originally published in Great Britain as Portrait Photographers Style Guide: The Recipe Book for Professional Portraiture Techniques by RotoVision SA, Hove.

Art Director Tony Seddon
Design and layout by Lisa Båtsvik-Miller
Illustrations by Robert Brandt, www.robertbrandt.eu

Printing and binding in Singapore by Star Standard Industries (Pte) Ltd.

About the Authors:

Peter Travers is a British photography journalist and author. Born in Bristol, UK in 1972, Peter has been working full-time in magazines and publishing for the past 14 years at Future Publishing in Bath, UK. He is currently Deputy Editor at *PhotoPlus*, Britain's fastest growing photography magazine, and is a respected authority on all things photographic. Peter regularly writes for *The Sunday Times*, BBC magazines, *Digital Camera* magazine, PhotoRadar.com, *T3*, and many other best-selling publications. He is also a published fiction author. Read more about him, and his contemporary novel, *TOP 10 HITS*, at www.petertravers.co.uk.

Born in Bath, UK, in 1972, James Cheadle began his career as a photographer at *The Bath Chronicle* newspaper in 1990. He went on to work for Solent News and Photo Agency in Southampton, supplying photographic material to the British national press, and in 1997 he moved to EMAP Publications as Picture Editor/Staff Photographer on *Total Sport* magazine, photographing many of the world's top sporting figures.

Since 2000 James has been working as a successful freelance photographer, and regularly undertakes commissions both throughout the UK and worldwide for a host clients in various media fields. James specializes in portraits, features, and automotive photography. His clients include *Q*, *USA Today*, *The Sunday Times*, *FHM*, *Loaded*, *Bike*, *Golf World*, *Today's Golfer*, *BBC Music Magazine*, *Motor Trend*, *Outside*, *Men's Health*, *T3*, *Performance Bikes*, *Test Drive*, and *Cycle World*.

The Portrait Photographer's Lighting Style Guide

Recipes for Lighting and Composing Professional Portraits

Peter Travers and James Cheadle

AMPHOTO BOOKS

an imprint of the Crown Publishing Group

Contents

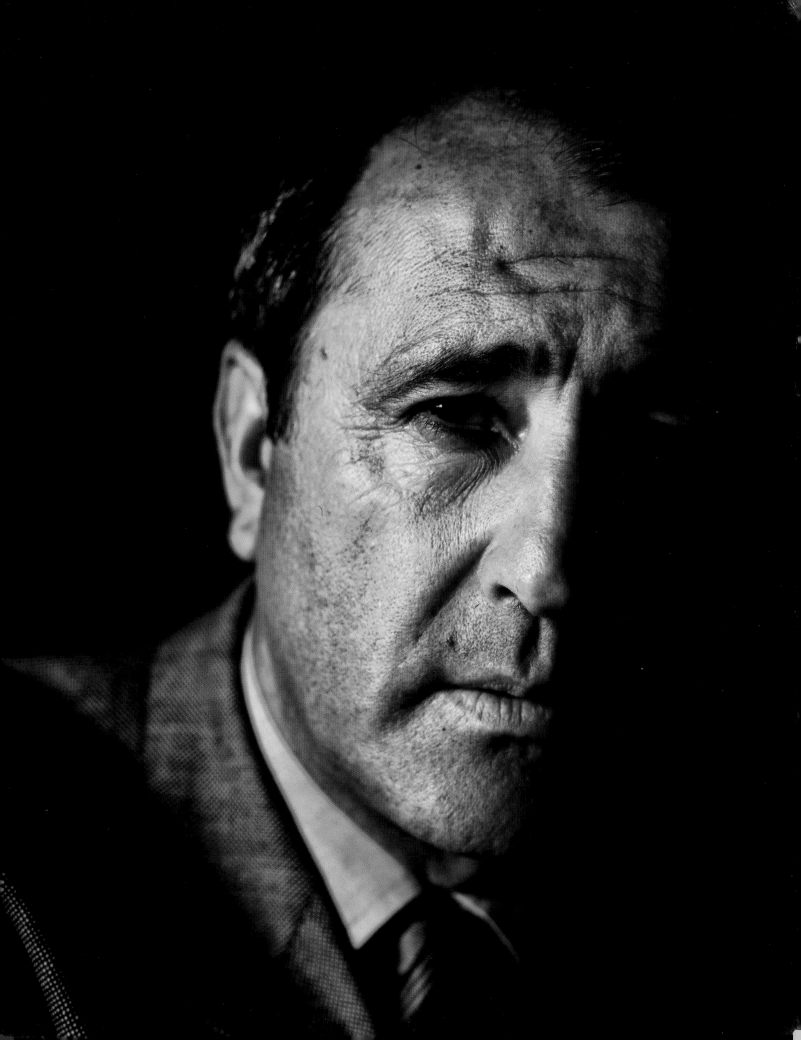

Introduction

Portraiture. It's the oldest style of photography and is still the most popular, yet it remains one of the most challenging to get right. In fact, the difference between a good portrait and a great portrait can be worlds apart in terms of creativity, class, and camera technique. With so many variables, many photographers find it intimidating and confusing when they set out to improve their portraiture skills. But it doesn't have to be this way.

Whether you're an ambitious amateur looking to increase your enjoyment of portrait photography, or a budding professional in need of a new set of exciting portrait styles to revitalize your portfolio, this book will help you to achieve your goals. Together we'll explore professional portrait techniques across a wide variety of popular styles and genres—from "gritty urban" to "pop culture," "action" to "classic Hollywood"—echoing the full range of images in today's media, advertising, and modelling shots.

All of the portrait styles featured in the book are broken down into easy-to-digest components with jargon-free advice and top professional secrets on lighting, exposure, and composition. Additionally, diagrams of the studio or outdoor setup provides you with a bird's-eye perspective on how the shot was achieved so you can easily re-create the same stunning style. You will also find a host of helpful shooting tips, equipment suggestions on the best kit to use and why, and dedicated Photoshop tutorials so you, too, can create new portrait styles in the digital darkroom.

With such a diverse group of portrait techniques in your repertoire, you'll soon have the confidence and photographic skills to collaborate with your models and capture a whole range of fantastic portraits, no matter how challenging the conditions or commission may be. So, shall we get started?

Key for Lighting Diagrams

 Softbox

 Ringflash

 Standard head

 Umbrella

 Camera

 Strip flash

 Natural indoor light

 Sun

 Board

 Flood

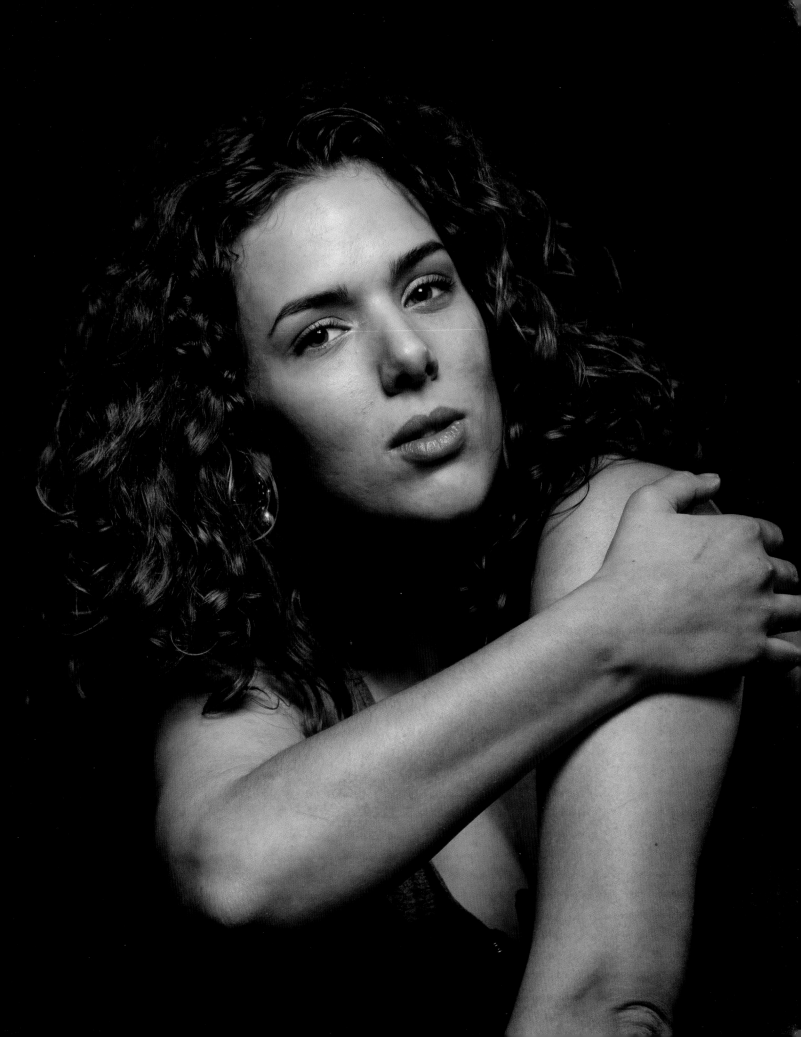

Portrait Styles

It takes years of hard work to learn the essential photographic techniques you'll need to capture specific portrait styles. It also takes years of experience to know which style to use according to your subject. That all adds up to a lot of time you're unlikely to have when somebody is standing there waiting for you to take their photograph.

This book can help. Our comprehensive guide to portraiture will help you to develop and improve your camera and lighting techniques, helping you to become a better photographer.

With 60 portraits spread over 120 pages, you'll find the inspiration you need to capture the right lighting and portrait style for the right photo. From editorial and advertising to period, corporate, full face, and black and white, there are portrait styles for every occasion. Featuring big names from Samuel L. Jackson and Angelina Jolie to Tony Blair and Zara Phillips, our professional portraits will help motivate you on your own shoots.

Enjoy.

Urban Sophistication

I was commissioned to photograph Jordanian DJ Ayah in a loft above a nightclub. The client was looking for a sophisticated lifestyle portrait that would suit its predominantly Muslim readership. The loft space had numerous possibilities, but I decided the big arched window would work best, as I could expose the shot for the moody, late evening sky and then light Ayah accordingly.

Lighting balance

It's always important to consider how the view through windows in your background will appear when shooting portraits indoors with lights. With the right balance, dramatic effects can be achieved. In order to enhance details in the evening sky, I slightly underexposed by using a shutter speed of 1/5 sec and an aperture of f/5.6. To achieve the sophisticated look my client was after, I then lit Ayah from the side using two studio lights.

To maximize the shape of the window I shot from down low and placed Ayah at the bottom of the frame. I managed to capture a more arresting image by positioning Ayah with her back to the camera and asking her to look over her shoulder.

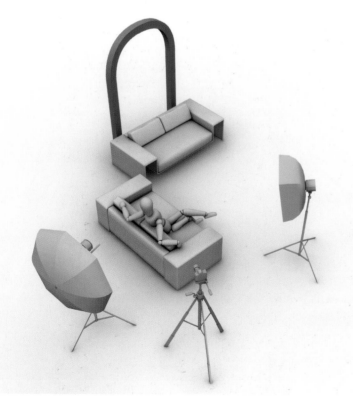

Camera	Canon EOS-1Ds Mk II
Lens	Canon EF 50mm f/2.5
Aperture	f/5.6
Shutter Speed	1/5 sec
ISO	100
Lighting	Bowens Esprit

Room with a view
Just because you're shooting your portraits indoors, don't forget about what's going on outside. Using a striking skyline view through a window to act as part of the backdrop could really help to enhance your shot.

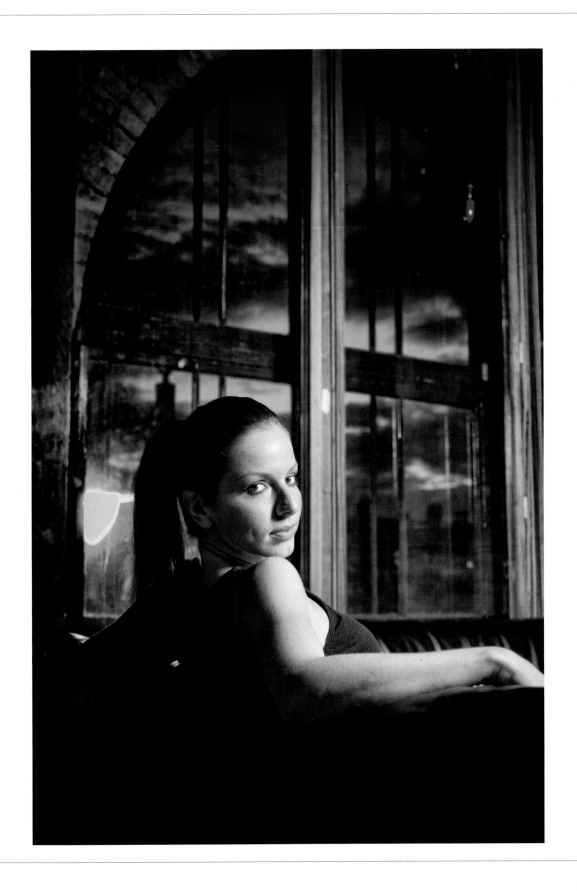

Gritty Urban

Professional soccer player Rio Ferdinand had just finished training when I shot this portrait. Because it was raining heavily I set up the photo shoot inside the sports hall and picked out a red brick wall as a backdrop. I decided to shoot in black and white in order to give the portrait a gritty feel. I got Rio to sit on a gym bench so he could rest his elbows on his knees and then asked him to put his fists together—this created a strong pose and helped to emphasize his strength of character. As Rio was due to attend a physiotherapy session I was limited to just 10 minutes for the entire shoot, so had to work very fast to get the shots.

Mood lighting

Whenever I decide to shoot using black-and-white film, I have to set up my lights in order to make the most of the film stock. The great thing about black-and-white images is that you lose all of the drab colors you would have contended with in poorly lit situations—instead, dull colors are quickly replaced with deep blacks and plenty of contrast.

I created a strong feel for this portrait by lighting Rio's face from above with a softbox and then putting spotlights on him from behind. I also put a spotlight on the brick wall, which captured detail in the background. I knocked the brick wall out of focus by shooting at a wide aperture of f/4 and at a long focal length of 110mm. To make the most of Rio's intense stare, I made sure I got down low enough so that my camera was at his eye level.

Camera	Mamiya RZ67
Lens	Mamiya 110mm f/2.8
Aperture	f/4
Shutter Speed	1/60 sec
ISO	400
Film	Ilford HP5
Lighting	3 Bowens Esprit 500 heads

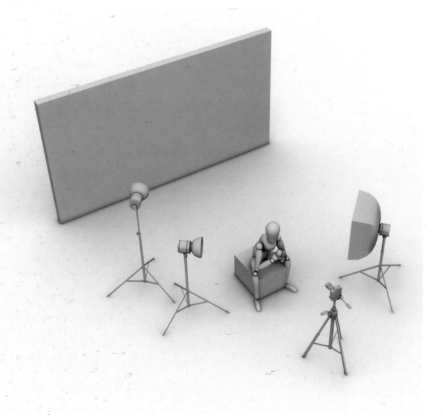

Hands up

People's hands and how they are positioned can help to reveal your subject's character on camera. For instance, getting your subject to rest their chin on their clasped hands, then look up, can create a more thoughtful portrait.

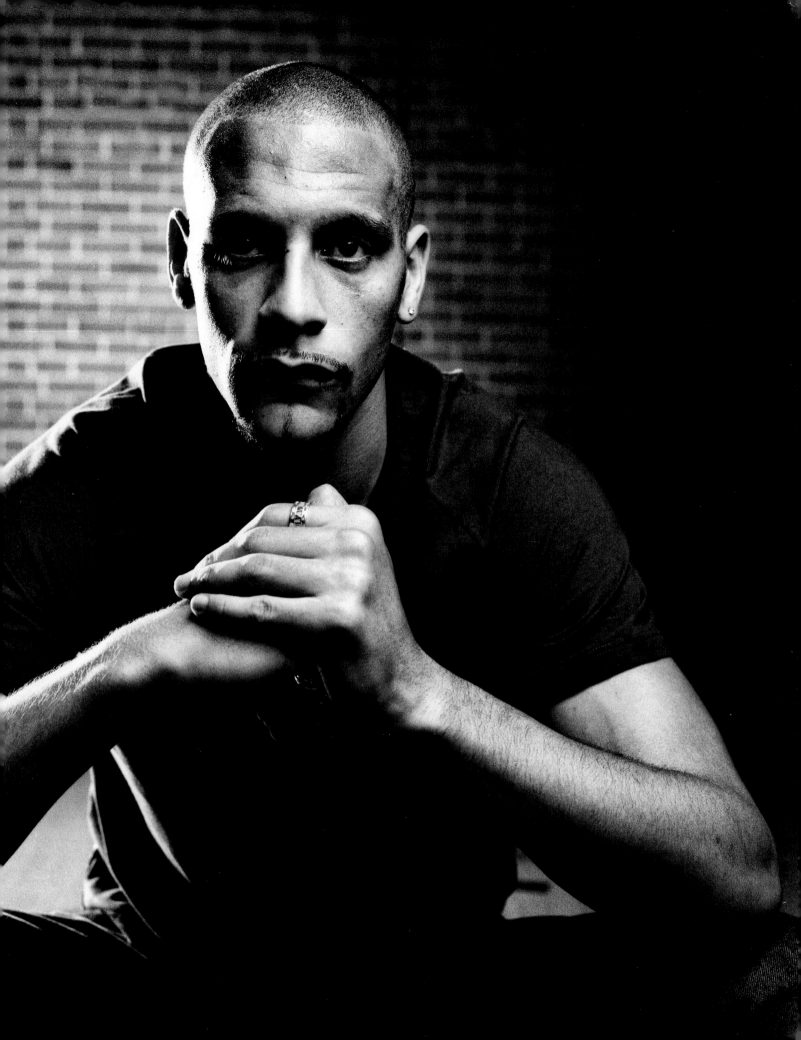

Gritty Urban

I met singer Ian Brown at his favorite café in London to shoot this portrait. Every shoot presents its own set of unique challenges, and for this portrait it was lack of space. Ian hadn't banked on the tiny café being packed with school children on vacation, which meant we were limited to a small table in the back for the entire shoot. Thankfully, Ian was in great form, constantly signing autographs for the children who recognized him not for being a singer and front man of The Stone Roses, but for his cameo in *Harry Potter and the Prisoner of Azkaban*.

Be ready to improvise

Cafés can make great locations for gritty urban portraits, particularly if they have interesting décor, such as the woodwork I used as a background in this shot. Sometimes it's the more dilapidated and worn-out venues that work best for atmospheric portraits.

Due to the limited space, I wanted to create a very natural, low-light effect, but still have complete control over exposure. To set up my main light source, and in order to keep my lighting cable off the ground for safety reasons, I hung a small Elinchrom Ranger Quadra AS lighting head off the lampshade above the table. The lampshade also acted as a brilliant directional softbox, delivering lovely, natural-looking light that helped to capture Ian's striking simian features as he reached up to the light.

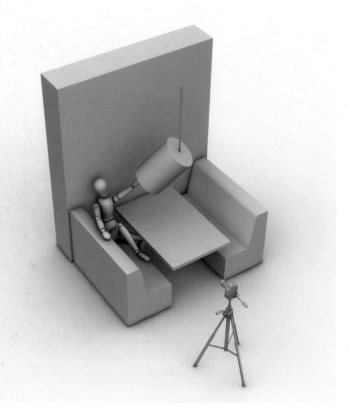

Camera	Canon EOS-1Ds Mk II
Lens	Canon EF 24–105mm f/4L IS @ 50mm
Aperture	f/5.6
Shutter Speed	160 sec
ISO	100
Lighting	Elinchrom Ranger Quadra A head

Thoughtful poses

You don't always need direct eye contact to make a great portrait. In fact, the opposite is often true. If you're looking to capture more thoughtful poses, ask your subjects to look off to one side.

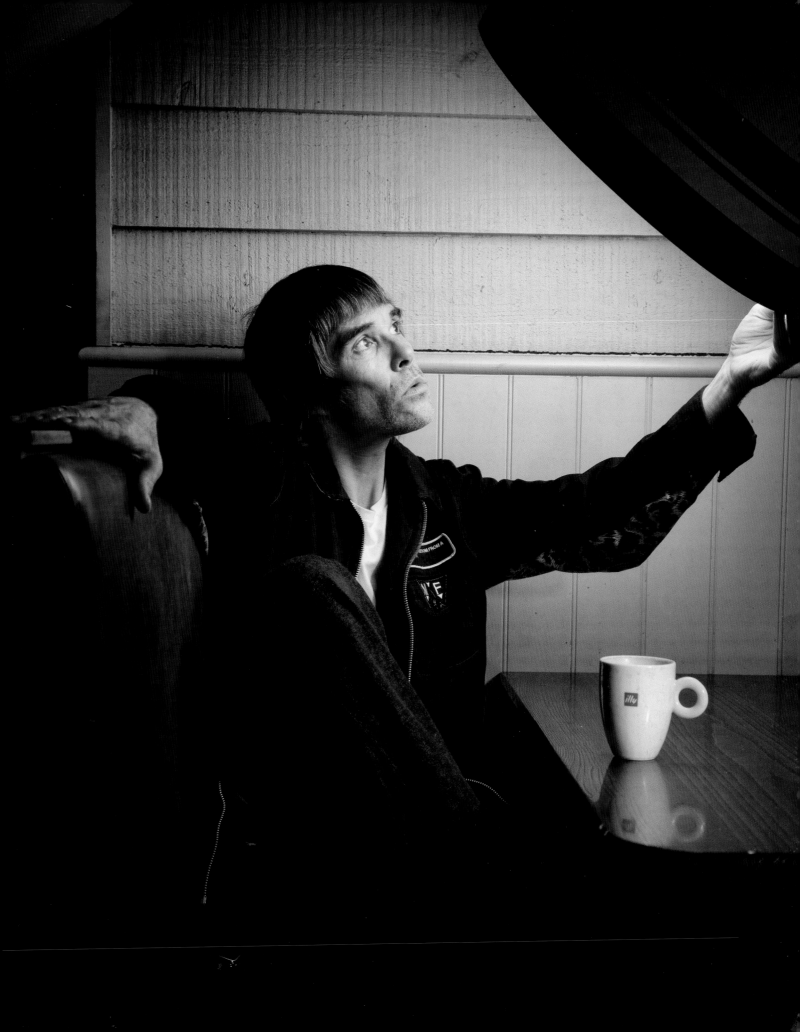

Pop Culture

I was asked to meet US-based DJs Deep Dish in their London hotel room to shoot this last-minute commission. It's quite common for artists to request to be photographed in their hotel room to avoid attention, but be aware that large hotels like lots of warning if you're planning to set up lights in their public areas. I shot a number of portraits of the two DJs, but the unusual effect I captured by shooting through venetian blinds produced the best results.

Camera shake

Believe it or not, I achieved this unique photographic effect in camera, without any clever Photoshop alterations. I positioned the subjects in front of the blinds and shot on the very slow shutter speed of 1/8 sec, setting the aperture to f/11 to expose for the light outside the window. As a result, you can just see a glimmer of the buildings outside the hotel.

I adjusted the power of the studio lights that were lighting the artists to correctly expose them at f/11, then during the exposure I quickly moved the camera from right to left to blur the available light spilling through the blinds, while still freezing the subjects with my studio lights.

Camera	Mamiya RZ67
Lens	Mamiya 110mm f/2.8
Aperture	f/11
Shutter Speed	1/8 sec
ISO	100
Film	Fuji Provia
Lighting	Bowens Esprit

Slow shutter speeds

When you've shot the pin-sharp portraits as specified in your brief, don't be afraid to experiment with slow shutter speeds to capture the movement and artistic images of your subjects. You may find your client actually prefers these shots to the originally requested, standard portraits.

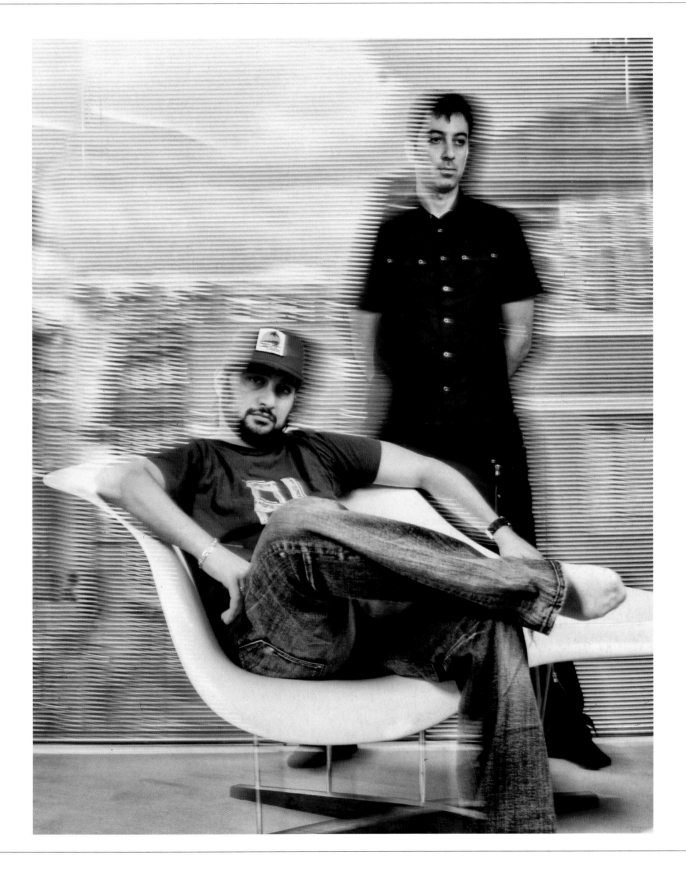

Pop Culture

I photographed singer-songwriter Gemma Hayes a few hours before she played a live show. It was a beautiful summer's day and there was a big blue sky begging to be captured, so I moved the photo shoot out onto a veranda and decided to shoot straight into the sun. It's always great to incorporate any available props, so we used Gemma's old acoustic guitar to add some extra context to the portrait.

Overriding the sun

Shooting into the sun can create great photographic effects, but when approached incorrectly it can produce disastrous results, so it's a practice that should be handled with care. Firstly, it's important that you expose for the sky in the background and then set up your lights accordingly. As it was a bright day, I needed to shoot with a narrow aperture of f/16 and a resulting shutter speed of 1/400 sec.

I composed my frame so that the sun was just to the left of Gemma's head. Fortunately, the sun was behind a thin layer of cloud that diffused its brightness, however without an artificial light source the subject would have been silhouetted, so I had to light Gemma with a large softbox from her right. To fully maximize the effect of the deep blue sky and reduce any unwanted city skyline in the frame, I lay on the floor and aimed up at Gemma to get my shot.

Camera	Mamiya RZ67
Lens	Mamiya 110mm f/2.8
Aperture	f/16
Shutter Speed	1/400 sec
ISO	100
Film	Fuji Provia
Lighting	Hensel Porty

Props make perfect

Keep an eye out for any props available that can help to enhance your portraits. If you're photographing musicians, for instance, getting their instruments in the shot can provide an instant point of reference.

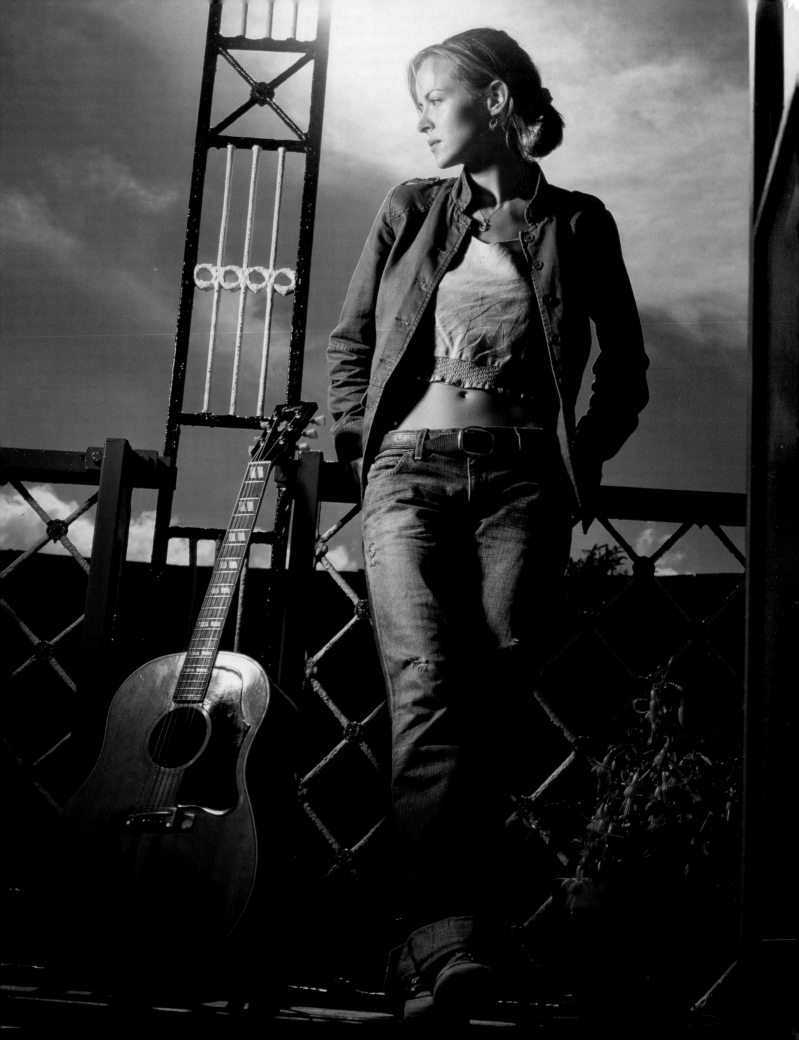

Advertising

This portrait of Ryder Cup team golfer Graeme McDowell was shot in a bar for a Ballantine's Scotch Whisky advertisement.

The main objective of any advertising shoot is to sell the product, so it's important to incorporate the brand name into the shot while still maintaining a mood that captures the image of the product. It's vital to work with your client so that this can be achieved with the required look, feel, and information. I also took shots with and without the bottles so the art director had different options for different markets.

Product placement

It was important to the client that the shot showed their whisky range in a refined but relaxed environment. I therefore felt it was best to keep the available light to a minimum and use directional lighting to create a sense of intimacy and draw the viewers' eye toward the product.

I used a three-light setup with a softbox to the left of Graeme's head, a grid highlighting his right cheek, and a softlight reflector was used to lift some of the detail out of the background. By focusing on Graeme and using an aperture of f/6.3, I was able to knock the first few bottles slightly out of focus, drawing the eye right into the center of the picture.

Camera	Canon EOS-1Ds Mk II
Lens	Canon EF 24–105mm f/4L IS @ 70mm
Aperture	f/6.3
Shutter Speed	1/20 sec
ISO	200
Lighting	3 Bowens Esprit heads

On reflection

Shiny and wet surfaces, whether indoors or outdoors, can provide you with the option of capturing reflections. This not only adds detail in what would otherwise be a blank and empty area in your frame, but also adds extra depth to your shots.

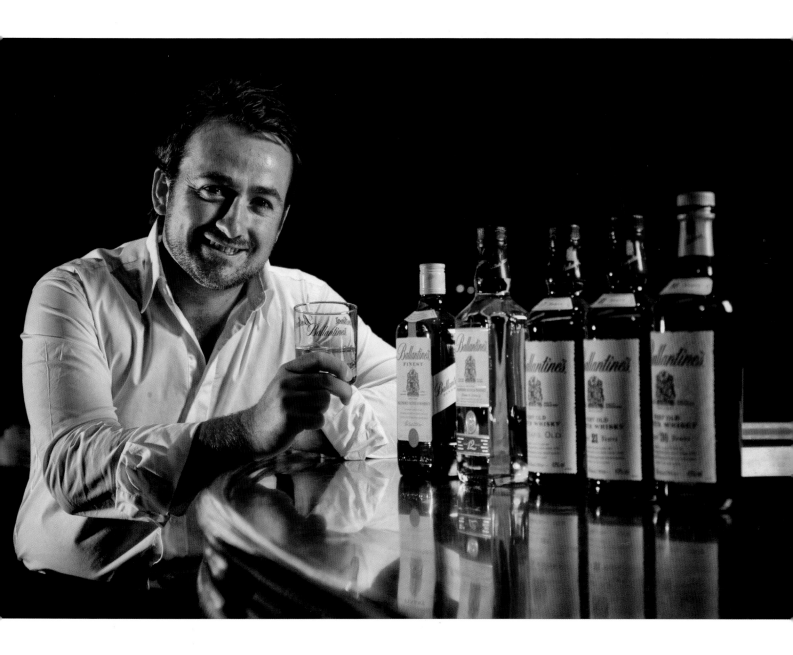

Advertising

I shot this portrait for a car modification business under a highway overpass. The client was very keen to inject an element of glamour, so we used a fashionably dressed female model to create a more stylish brand image.

Although this was shot on a bright summer's day, I used my Hensel portable battery-powered lights to illuminate the model from the left of the frame and to highlight the wheels and custom paint job featuring the company logo on the Chrysler car.

Converging lines

An important factor to remember when composing outdoor portraits like this is to work with all of the lines available in the background. I used the curves of the overpass in the top of the image to draw the eye to the main subject—this way the background is working with, rather than against, the girl and car in the foreground. I also composed the shot to include the dark area under the overpass for the client to add text to their advert. To give the sky a boost, I accentuated and darkened the contrast and clouds using the Burn tool in Photoshop.

Camera	Canon EOS-1Ds Mk II
Lens	Canon EF 24–105mm f/4L IS @ 40mm
Aperture	f/9
Shutter Speed	1/250 sec
ISO	100
Lighting	Hensel Porty

Get ahead in advertising

A more conventional automotive advert would have perhaps captured the model pouting at the camera, possibly sprawled across the hood. A much classier result has been achieved here with the model standing next to the car and giving a subtle look over her shoulder.

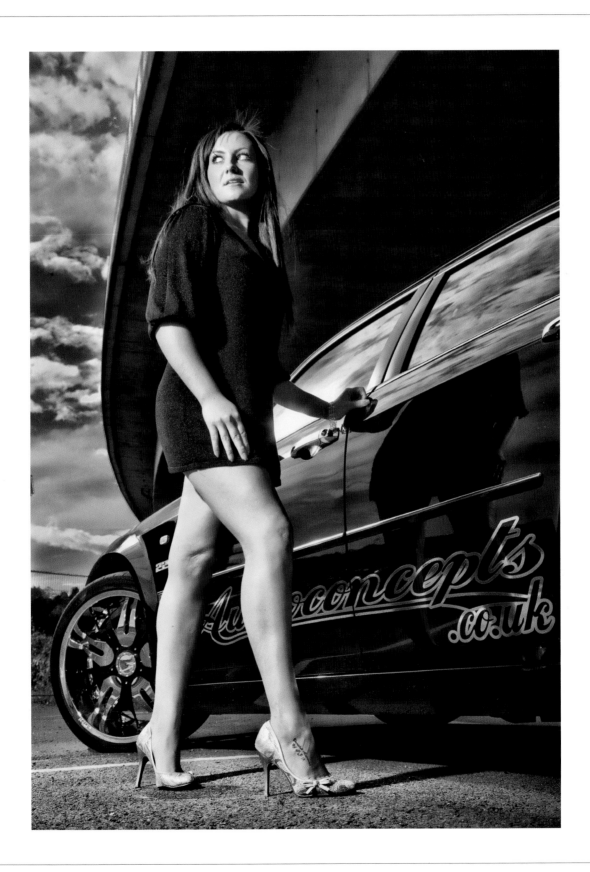

Editorial

I photographed Zara Phillips, 2006 Eventing World Champion and member of the British Royal Family, for *HELLO!* magazine. *HELLO!* asked me to take Zara's portrait alongside her gold-medal winning horse, Toytown. The shoot took place on the Sandringham Estate, the Norfolk retreat of Her Majesty The Queen.

It was a horrible gray, wintry day, so lighting was essential. Due to the hazards of trailing cables in a stable, I used just one Hensel battery-powered head with a 24 × 24in/60 × 60cm softbox to light Zara and Toytown from the front-right of the frame. I used the darkness of the stable to create a clean, black backdrop that surrounded Zara and Toytown. I included this blank space in my composition specifically for *HELLO!* so they could run white text over this area.

Animal magic

Working with animals is notoriously tricky and can bring a whole set of new challenges to a shoot. As well as remaining sensitive to the needs of your human subject, you have to be constantly aware of the unpredictability of having an animal on location. It's important to be in communication with the animal's keeper at all times in order to understand where the boundaries are and ensure everything runs smoothly. Horses can be particularly sensitive to strobe lighting, so it's vital that you keep checking they are calm and at ease with your flashing lights. Thankfully Zara's faithful horse Toytown was completely at ease in front of the lens. He even poked his tongue out at me, as you can see in the shot!

Camera	Canon EOS-1Ds Mk II
Lens	Canon EF 24–70mm f/2.8L @ 60mm
Aperture	f/6.3
Shutter Speed	1/50 sec
ISO	100
Lighting	Hensel Porty

Space for text

When shooting portraits for editorial publications, it's important to know whether you should compose your shots so that they allow space around your subjects for headlines and body text. Always check with your client beforehand.

James Cheadle

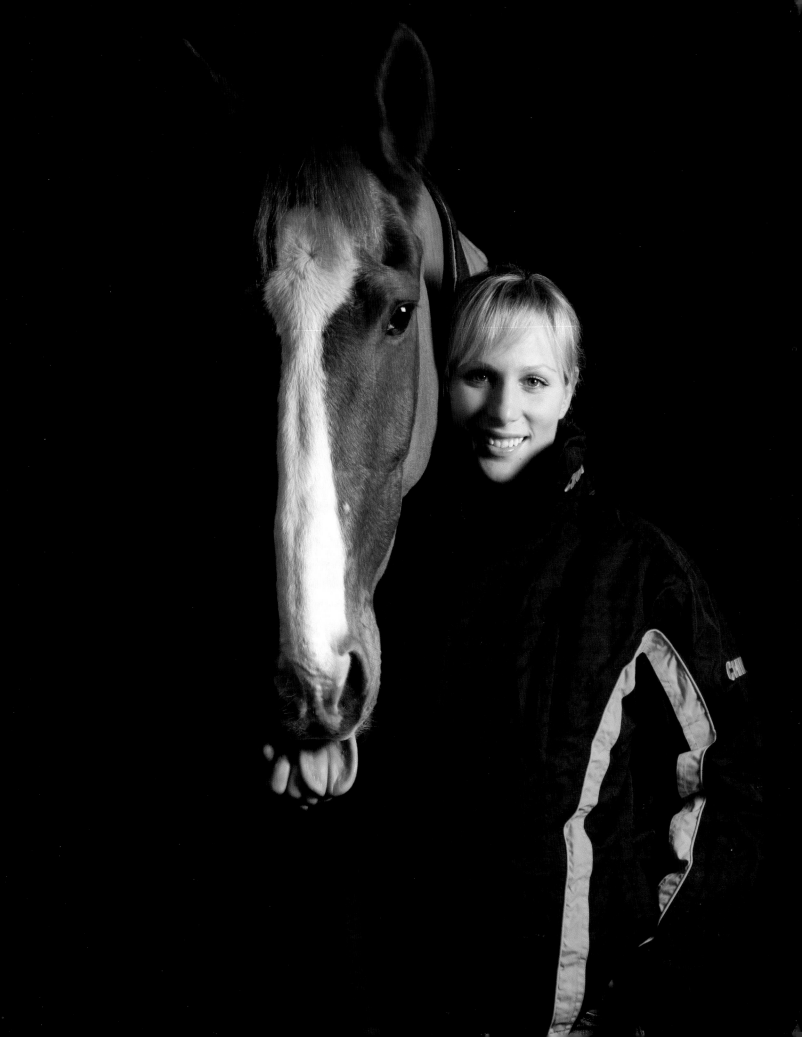

Editorial

I was commissioned by the British Labour Party to take a publicity portrait of Tony Blair for them to use in the run up to the 1997 general election—when Tony Blair led Labour to win their first national political campaign for 18 years. The photos had to be newspaper-friendly and show Tony in an energetic and patriotic pose. The shot was taken during one of Tony's speeches, so I was limited to one flash mounted on my camera, which injected some energy into the portrait.

Careful framing

To create an active editorial feel, the client requested that I shoot the portrait live during Tony's speech. This meant that I was limited to one flash mounted on my Canon 35mm film SLR. Because of the lack of lighting control, it was crucial that I create a striking composition to ensure the image caught the eye of the newspaper picture editors. Framing Tony's face in the middle of the Union Jack flag means that all of the lines in the flag draw your eye into the middle of the shot, where I had positioned Tony in the frame.

Camera	Canon EOS-1N
Lens	Canon EF 80–200mm f/2.8L @ 200mm
Aperture	f/2.8
Shutter Speed	1/160 sec
ISO	400
Film	Fujicolor Pro
Lighting	Canon Speedlite flash unit

Vertical or horizontal composition

The shape your editorial portrait needs to be is a simple, but important, point to consider. Always check with clients beforehand if the shots need to be horizontal (landscape) or vertical (portrait).

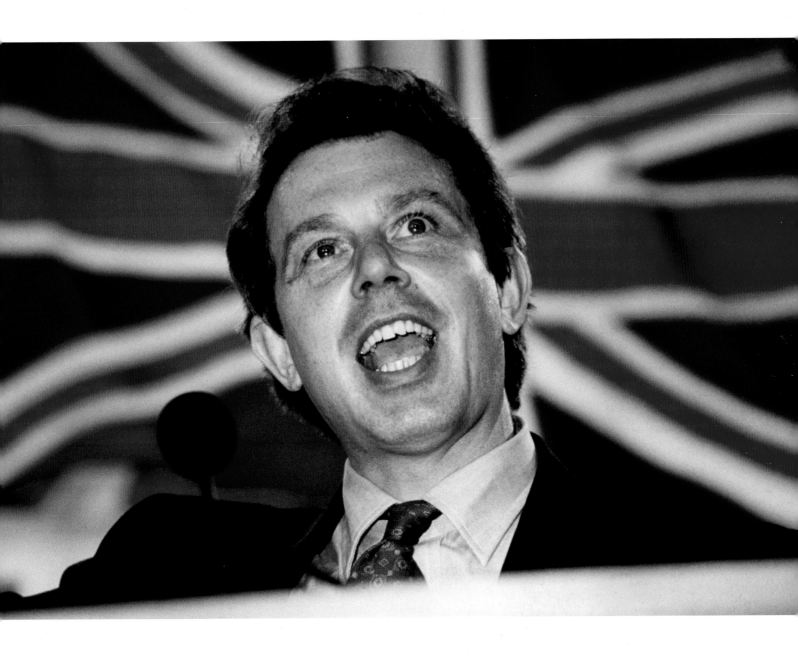

Beauty

When photographer Ed Godden wanted some new images to strengthen his portfolio, he arranged to photograph Maggie, a local model, through the model-photographer networking site Model Mayhem. The site encourages everyone to work free of charge on a trade basis—you get a fresh-faced model to photograph and the model gets professional-quality images. It's a good way of helping to enhance each other's portfolios.

Maggie was keen to build her beauty portfolio, so she and Godden decided her black-and-white striped dress would be perfect for this style of portraiture. To make her face stand out she applied some strong eye makeup and Godden asked her to frame her face with her arms. Taking the fantastic bold stripes on her dress as a starting point, the model and photographer experimented with a few geometric and funky poses before settling with this great look.

Soft lighting

Godden lit the shot in his studio by placing one large Bowens softbox to his left, positioned high up and looking down on Maggie, which created a soft, even light over her face and hair. By facing an 8ft/2.5m-high black polystyrene board toward Maggie's back, he ensured the light wasn't reflected off the white walls onto her hands, neck, and back. As these areas appear darker, it helped to create greater depth within the shot.

For optimum quality Godden always uses prime lenses in the studio, and for this portrait he used a 60mm f/2.8 lens. When processing the shot in Photoshop, he decided to crop the bottom of the dress off as he felt it took away the impact of having the stripes on a plain background.

Camera	Nikon D300s
Lens	Nikon 60mm f/2.8 AF Micro-Nikkor lens
Aperture	f/14
Shutter Speed	1/160 sec
ISO	200
Lighting	Bowens head with softbox

Light meters versus histograms

Photographers used to rely on handheld light meters to take meter readings of their subjects in order to help set the correct exposure. Modern DSLRs have built-in metering, but to be certain you can also use the histogram on the LCD screen to check your exposures.

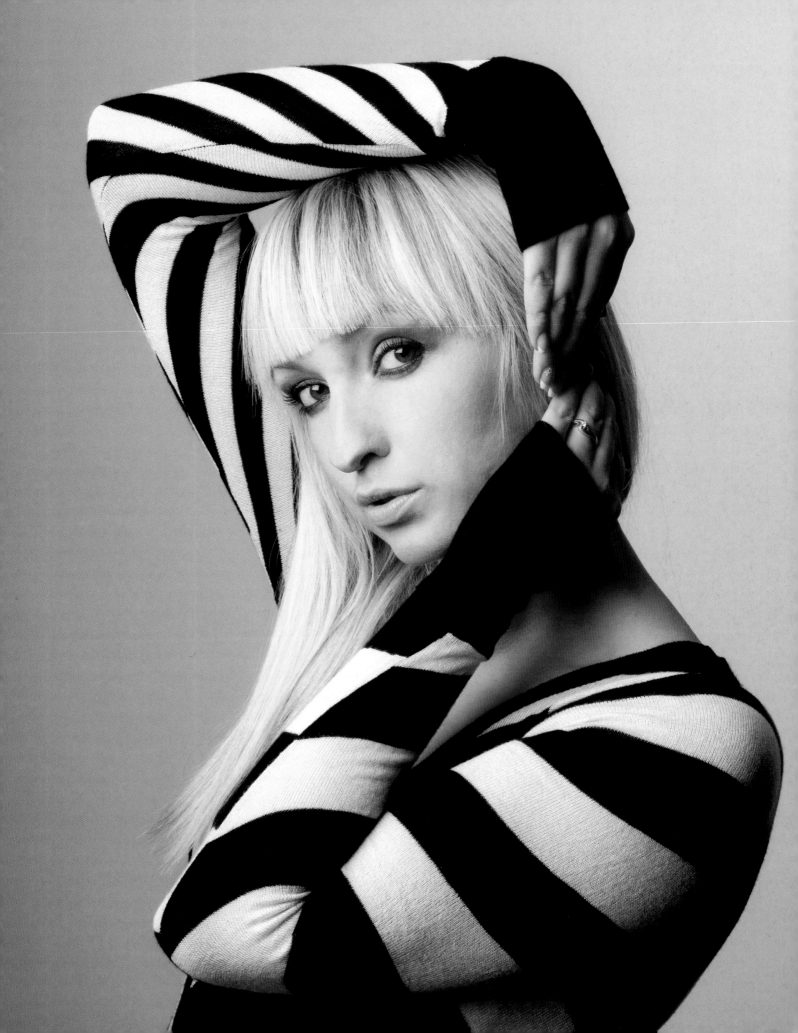

Natural

While shooting a lawn mower racing event in Buckeye, Arizona, I got chatting with one of the mechanics. As I was shooting for a lifestyle feature, I asked the mechanic if I could take his picture. He gladly agreed, and I decided to photograph him without any lights. Artificial flash opens up a whole new world in portraiture, but there are times when the best light source in the world is natural light. This can be a great way of capturing real life in its natural environment, warts and all.

Getting that natural look

Some subjects just scream out to be photographed using natural light, and this was one of them. I got this shot literally in a matter of seconds—the mechanic scooped up his dog and baby boy and I snapped away using my DSLR's Continuous Shooting mode. I used a telephoto lens at f/2.8 to blur the background and focus attention on the subject.

It's important to work quickly in order to get a good natural portrait, so always ensure your camera is set up ready to go and that you're confident with your exposure settings. For this shot I used the Tv shooting mode (aka Shutter Priority) on my DSLR, setting the shutter speed to 1/250 sec to ensure I achieved sharp shots with the focal length of 120mm.

Camera	Canon EOS-1Ds Mk II
Lens	Canon EF 70–200mm f/2.8L IS @ 120mm
Aperture	f/2.8
Shutter Speed	1/250 sec
ISO	200
Lighting	Natural light

Blur-free shots

When shooting portraits handheld and with a telephoto zoom lens, make sure your shutter speed is equal to or higher than your focal length to ensure sharp shots. For instance, a focal length of 200mm needs a shutter speed of at least 1/200 sec or faster.

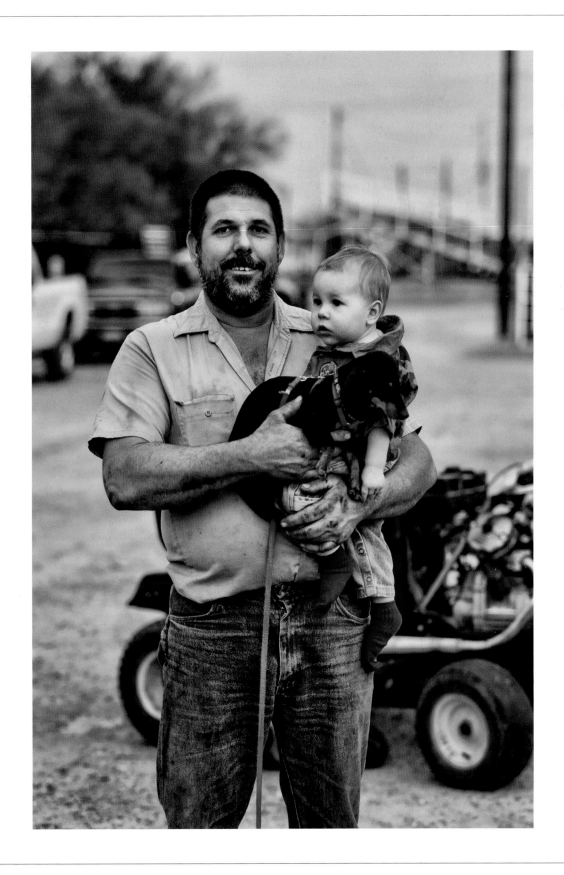

Youth Magazines

I was commissioned to photograph DJ Hyper while he was on tour in Florida. I needed to produce a portrait that told the story of life on the road in America. This shot was taken at an old auto repair shop between Tampa and Orlando, and the owner of the workshop kindly let me use his classic Buick as a prop in my shoot.

I was able to shoot straight into the midday sun using a Hensel Porty battery-powered light and accurately exposed DJ Hyper as he lounged casually on the hood of the car.

Shooting into the sun

Shooting into the sun can be a risky business, but handled correctly it can produce stunning results. To capture the striking flare from the sun in this portrait I used a Cokin Starburst filter, popular in the 1970s, but still useful in certain portrait photo situations. I used one Hensel light off to the left of the frame to light DJ Hyper.

Lying on the road in front of the Buick, I framed everything around the car's chrome grill and the sun in the sky, with my camera set to expose correctly for the bright sky. The end result is a powerful photograph with vibrant colors.

Camera	Mamiya RZ67
Lens	Mamiya 55mm f/4
Aperture	f/18
Shutter Speed	1/60 sec
ISO	50
Film	Fuji Velvia
Lighting	Hensel Porty single head

Telling a story

Using props in your portraits can help to quickly tell a story so that readers instantly know what the magazine feature is about. As this example shows, there's nothing better than a classic, chrome-filled American gas-guzzler to say "Life on the road in the US of A."

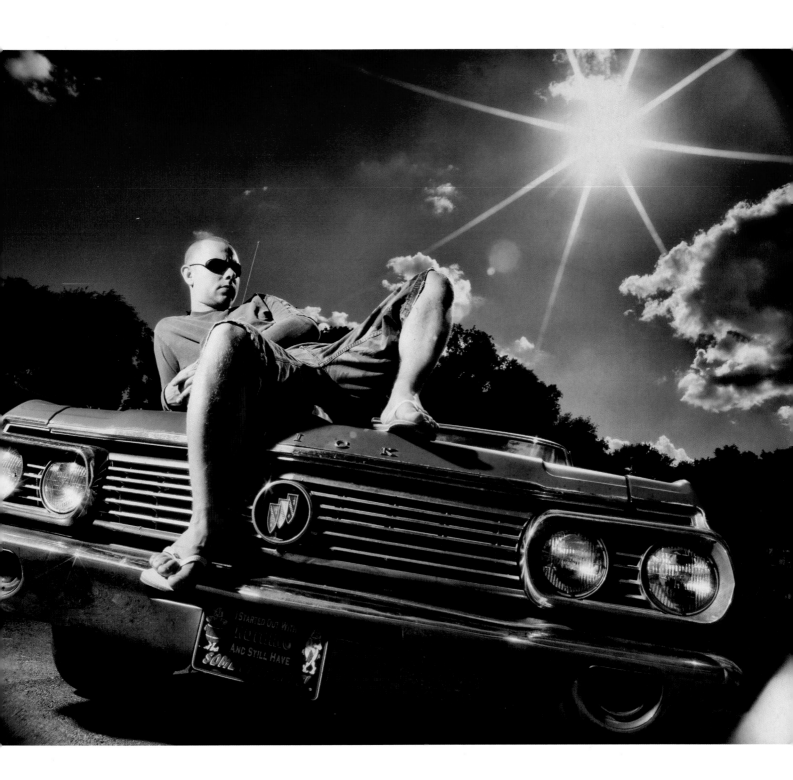

Youth Magazines

This portrait shoot was set up in a nightclub during the day when the venue was closed to the public. The brief from my client, *International DJ* magazine, was to produce an eye-catching cover shot of DJ Lottie, a presenter on BBC Radio 1.

I worked on a number of different setups with Lottie during the shoot, but this unusual opening in one of the interior walls was the perfect spot for the cover shot. I composed the portrait with Lottie in the center of the frame, leaving enough of the freckled wall at the top and bottom for the magazine's masthead and cover lines.

Adding color

The circular hole in the nightclub wall presented a great opportunity for a strong image. As a photographer I often have to think on my feet, and have learned to recognize potential shots very quickly. In this instance, I noticed that the colors in the frame were very dull for a cover, so I decided to add some red in order to bring the portrait to life. I did this by adding a simple red gel over my Bowens light, which I positioned to backlight Lottie. I also lit her from the front by placing a large rectangular softbox above her.

Camera	Mamiya RZ67
Lens	Mamiya 110mm f/2.8
Aperture	f/5.6
Shutter Speed	1/60 sec
ISO	100
Film	Fuji Provia
Lighting	Bowens Esprit

Question of color

In photography it's important to know which colors work well together, which colors contrast, and which colors clash. In this example, DJ Lottie's cyan T-shirt, navy jeans, and white sneakers worked brilliantly against the black background and concrete wall.

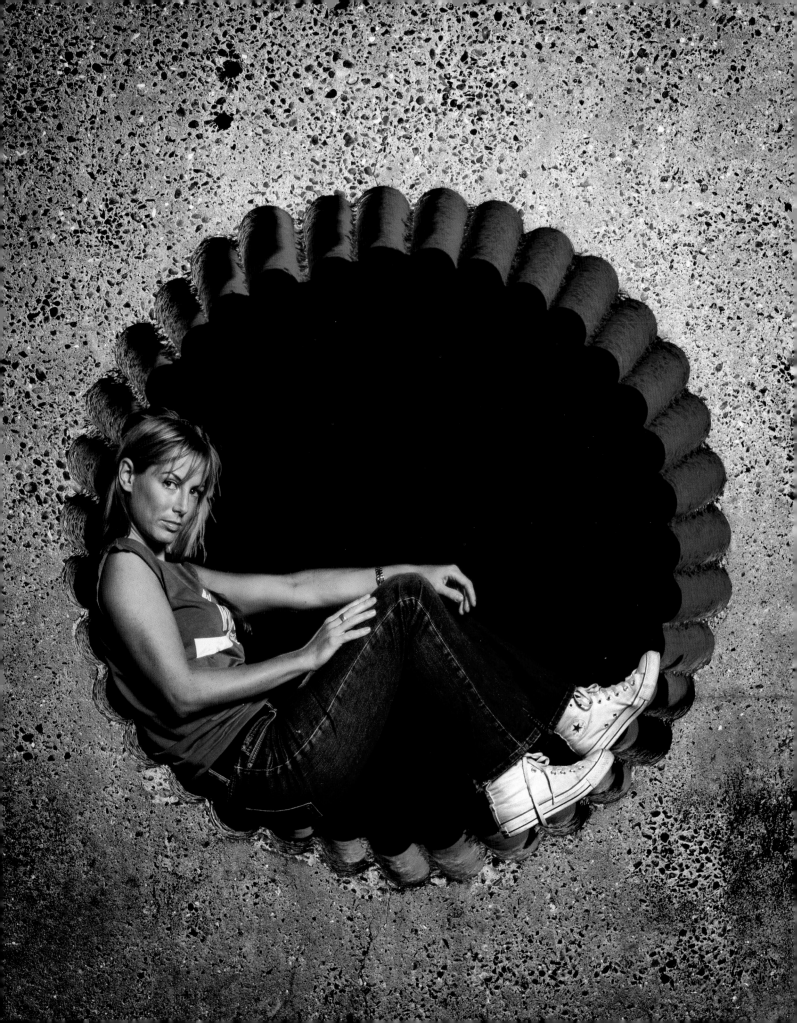

Period

Period-style portraits can be a lot of fun when they're organized well and shot correctly. This photo of a Victorian golfer was taken for *Today's Golfer* magazine to illustrate how the sport has evolved over time.

The shot was lit simply with two battery-powered Elinchrom Ranger Quadra heads—one positioned off to the right of the frame and one lying on the ground behind the golfer. I lay down on the grass so that I could have the sky in the background and a hint of heather in the foreground, and to keep the focus on the golfer.

Getting the look

If you are planning a period portrait photo shoot, it's essential to research the exact look and era you're trying to capture. There are different ways of sourcing costumes for your shoot, but the best way to guarantee an authentic look is to rent your outfits from an established costume props company. Most major cities will have outlets, but it's important to plan ahead and reserve them so that the correct clothing/props are available on the day of your shoot.

Also make sure your shoot isn't let down by poor choice of location—if any architecture is included in your shot, for instance, make sure it matches your subject's attire and the period of your portrait.

Camera	Canon EOS-1Ds Mk II
Lens	Canon EF 24–105mm f/4L IS @ 55mm
Aperture	f/8
Shutter Speed	1/60 sec
ISO	100
Lighting	Elinchrom Ranger Quadra

Dress to impress
The clothes your subjects wear will have a big impact on your portraits. If necessary, ask people to change outfits, politely explaining that you feel it will enable you to better capture their personality or match the brief.

James Cheadle

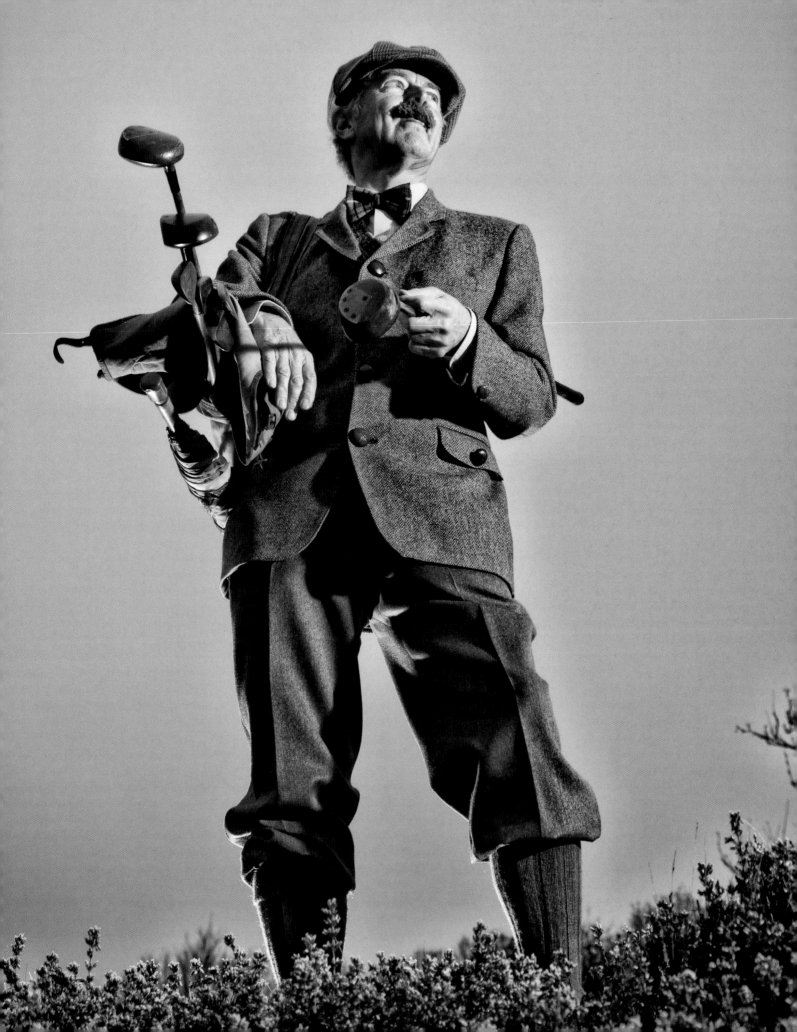

Period

I was lucky enough to have access to the beautiful Villa Valmarana ai Nani in Vicenza, Italy, for this *BBC Music Magazine* cover shoot with world-famous pianist Angela Hewitt.

As well as the seventeenth-century frescoes that adorn the walls of this incredible building, I also had a full-size Fazioli grand piano delivered to help create the period look. I employed a stylist to work with Angela to ensure her outfit was in keeping with the portrait style we were trying to capture. I used a simple setup with a large softbox lighting Angela, and a Bowen Esprit head filling the back of the room with light.

Location hunting

When shooting period-style portraits, location is everything. The key to getting it right is to research the area where the shoot will take place and discuss all of the details with your client. Consider using location agencies to help with sourcing places and arranging access to a range of suitable locations.

When shooting in historical buildings, you may have to be careful with your lighting as short, sharp blasts of direct light can damage old paintings. To get around this I use reflectors and softboxes at all times.

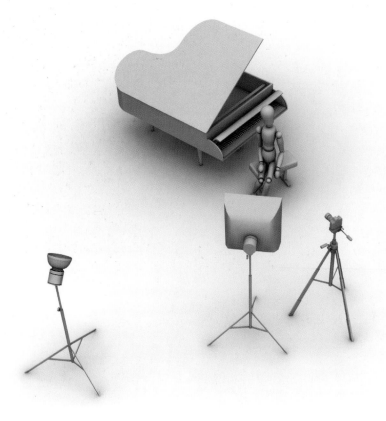

Camera	Canon EOS-1Ds Mk III
Lens	Canon EF 24–105mm f/4L IS @ 35mm
Aperture	f/8
Shutter Speed	1/80 sec
ISO	100
Lighting	Bowens Esprit

Beautiful backdrops

If the location you're shooting in has photogenic potential, such as a striking interior or stunning outdoor scene, don't be afraid to compose your portrait so that your subject complements the setting rather than dominates the whole frame.

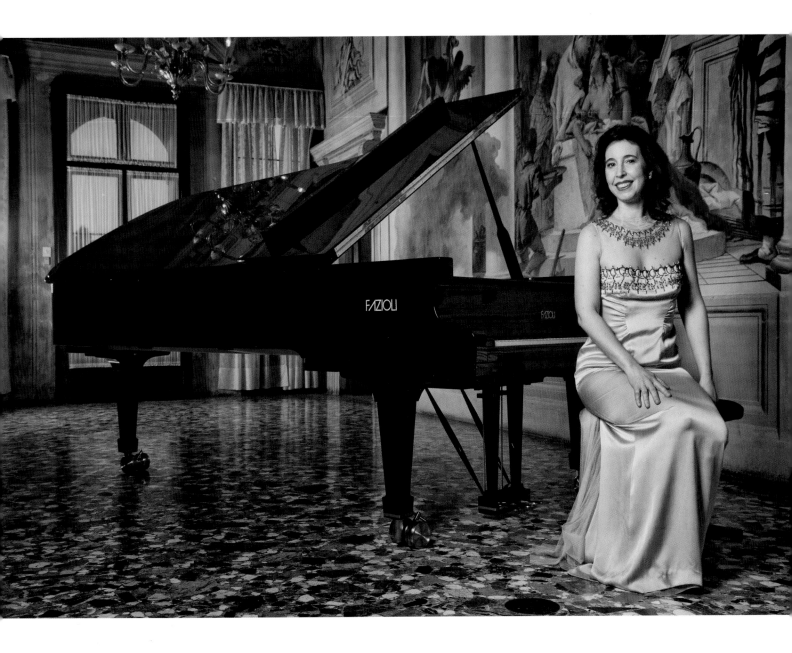

Haute Couture

This haute couture–style portrait was part of a fashion series taken in Paris. With the help of her location manager, Bronia Stewart spent two days scouting various locations in and around the 11th and 12th arrondissements of Paris. They chose this street location with its simplicity and great textures to act as an uncomplicated backdrop that would work well with the outfits. The stylist for the shoot chose vintage clothes in dark colors, which contrasted well with the lighter background and the model's coloring.

Shooting below freezing

To keep this shot simple, Stewart chose to use one flash head placed behind the model's right shoulder, which cast a shadow across her body and created highlights in her hair.

The conditions on the shoot were incredibly demanding—it was minus two degrees and snow was forecast for later in the day. Battery life is drastically reduced in cold conditions, so Stewart's assistant had spare camera batteries keeping warm in his inside pockets throughout the shoot, and they also wrapped a Profoto Pro-7b battery pack in insulation to prevent it from getting too cold and malfunctioning.

The model waited in a nearby cafe and was only called to the set once Stewart was ready to shoot, and the makeup artist was constantly on hand to try and prevent the model's skin and nose from turning red from the chill!

Camera	Nikon D70s
Lens	Nikon AF-S DX 18–70mm f/3.5–4.5
Aperture	f/6.3
Shutter Speed	1/250 sec
ISO	200
Film	Ilford HP5
Lighting	Profoto Pro-7b lighting kit

Preparing for the weather

Always take at least two spare batteries with you on all shoots. This is even more important when shooting portraits outdoors in cold conditions, when battery life is seriously reduced.

Classic

I met German tennis star Boris Becker in Milan, Italy, for this photo shoot at a Davis Cup match. When I arrived on location I was told my time to shoot was going to be cut short due to unforeseen reasons. In the end I had three minutes with Boris to capture a top portrait shot.

Luckily for me, Boris arrived looking immaculate in a classic black suit, white shirt, and burgundy tie, with his hair smartly styled. This meant I at least knew he'd look good on camera, and all I had to do was quickly get the shot.

Working under pressure

While en route to Milan I was advised I would be given 20 minutes with Boris, but as often happens, plans change. This is why, when I'm working with personalities, I always arrive early—very early—to ensure that my studio lighting setup is tested and my camera kit is accurately configured and ready to go.

I got my assistant to stand in as a model for some test shots to ensure that everything was working correctly and so I would be ready to quickly get the shots when Boris arrived. With such a small amount of time it was important that I kept things simple. My setup included just one softbox off to the left of the frame, which created a classic feel, and I draped a black sheet over the back of the seating stands to create a simple, uncluttered background.

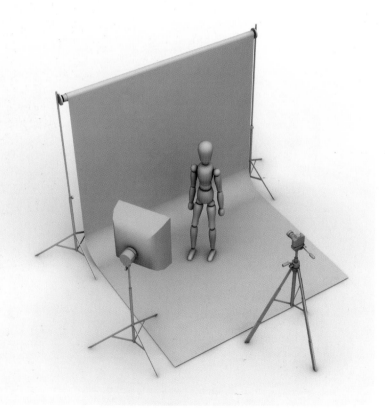

Camera	Canon EOS-1N
Lens	Canon EF 70–200mm f/2.8L @ 100mm
Aperture	f/8
Shutter Speed	1/200 sec
ISO	50
Film	Fuji Velvia
Lighting	Bowens Esprit

Keep it simple
When time is tight, be smart and keep your studio setup simple. Some of the best portraits are taken with minimal equipment, such as one light with black fabric, or a roll of paper used as a backdrop.

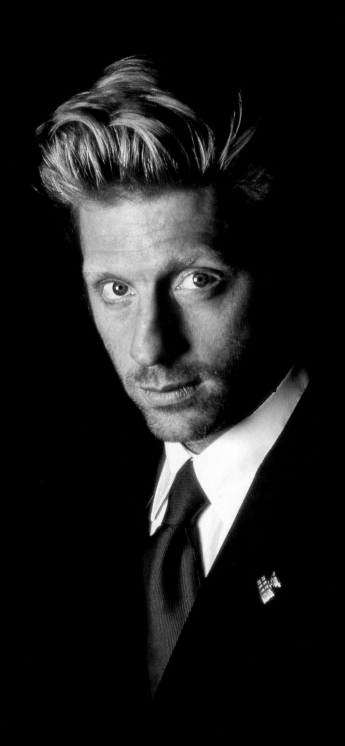

Classic

This shoot was commissioned by the BBC a few hours before Russian baritone Dmitri Hvorostovsky was due to perform at the Royal Opera House in London. I felt this portrait needed a classic feel due to the nature of the location and Dmitri's reputation as a world-famous baritone. I positioned Dmitri at the top of an ornamental staircase leading up to one of the Royal Opera House's main function rooms.

Shooting at a focal length of 170mm on a telephoto lens at an aperture of f/2.8, I was able to blur the ornate chandeliers in the background to create a classic, elegant look. I used a medium-sized softbox to light Dmitri's face and placed a grid behind him to highlight his amazing silver hair.

The classic look

It's important to recognize which portrait style best suits your subject. For Dmitri, it was obvious to me that he would be perfect to photograph in a simple, classic setup. When photographing in this style, pick your location wisely and be aware of what is going on in the background. Decide what to include or exclude—for this shot I included the row of chandeliers in the background to add a touch of decadence.

This portrait of Dmitri also shows him looking off camera. To get the most out of your subjects, eye contact isn't always essential. In fact, sometimes you can capture your subject's persona better shooting this way.

Camera	Canon EOS-1Ds Mk III
Lens	Canon EF 70–200mm f/2.8L IS @ 170mm
Aperture	f/2.8
Shutter Speed	1/125 sec
ISO	200
Lighting	Bowens Esprit

Get to know your location
If you're shooting in new locations, always arrive 30 minutes early so that you can wander around and get a feel for the place, and also so that you can look for photogenic areas in which to capture your subjects.

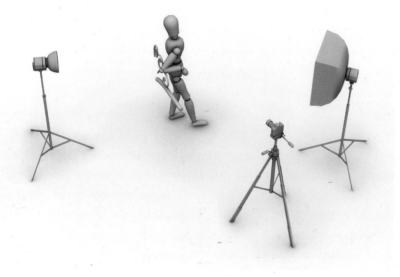

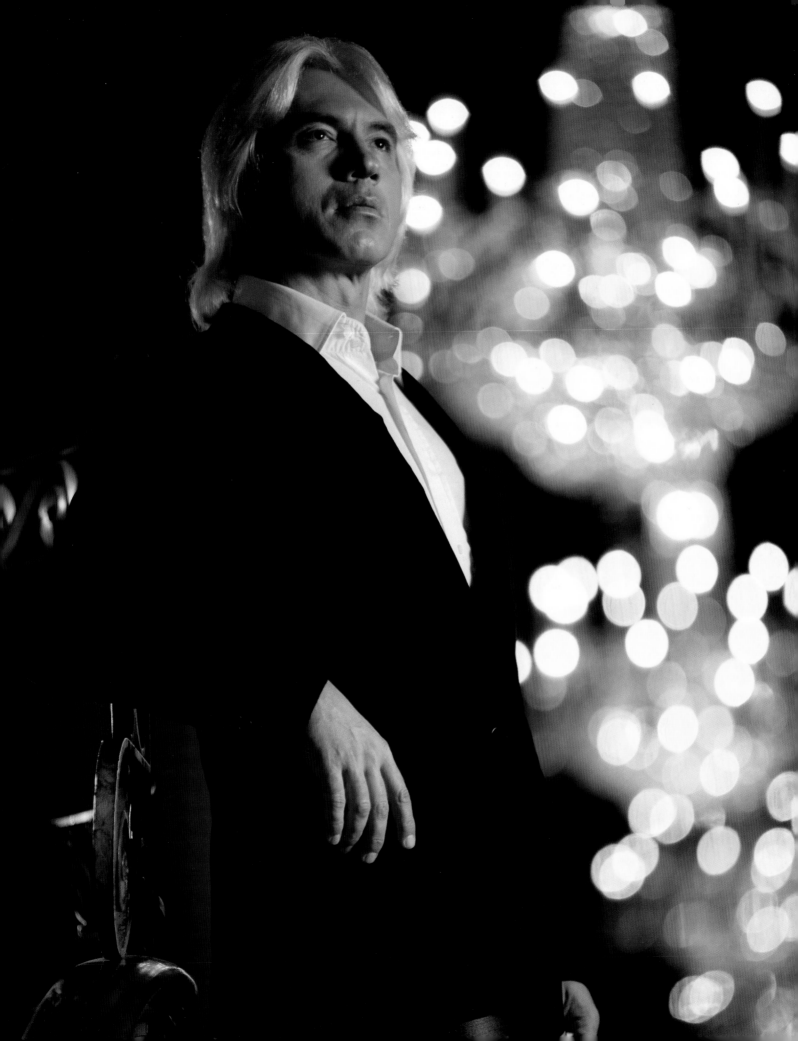

High Tech

Adrian Myers shot this portrait of Olympic gold-medal athlete Christine Ohuruogu for *SPIKES* track-and-field magazine over a two-hour session in my studio. The brief was to create a high-tech, futuristic feel, so Myers decided to mix flash lighting (to get a sharp portrait) with continuous lighting in order to capture the hoops of light around her.

Lord of the rings

Before Christine arrived Myers photographed the fluorescent ring lights with the camera locked on a tripod. He then suspended the ring light and moved it up and down, shooting ten different exposures from the top to the bottom of the frame, which would provide the different angles of view needed to simulate them around her body. Myers placed two Elinchrom strip lights either side of Christine and two clip lights behind her, with Tulip reflectors and grids placed to highlight her hair and body.

Myers processed the portrait image twice using Hasselblad's Phocus software. He balanced the first image correctly for the flash, and the second one was processed with a tungsten balance to create a blue tint. The two were then blended in Photoshop to give a mix of blue and clean light in the right areas. After this, seven of the hoop images were added and blurred, and all of the layers were tweaked so that the hoops and colors mixed effectively with Christine's portrait.

Camera	Hasselblad H3DII-39
Lens	Hasselblad 80mm f/2.8
Aperture	f/11
Shutter Speed	Varied from 1/2 sec to 1/500 sec
ISO	50
Lighting	Elinchrom and fluorescent light tubes

Tinted love

Using Photoshop (or other image-editing software) to add colored tints to your images is a great way of quickly transforming portraits and giving them a different look and feel. For instance, use blues and greens for a cool, fresh result, or oranges and reds for a warm finish.

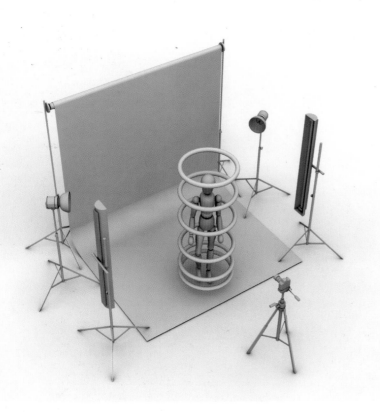

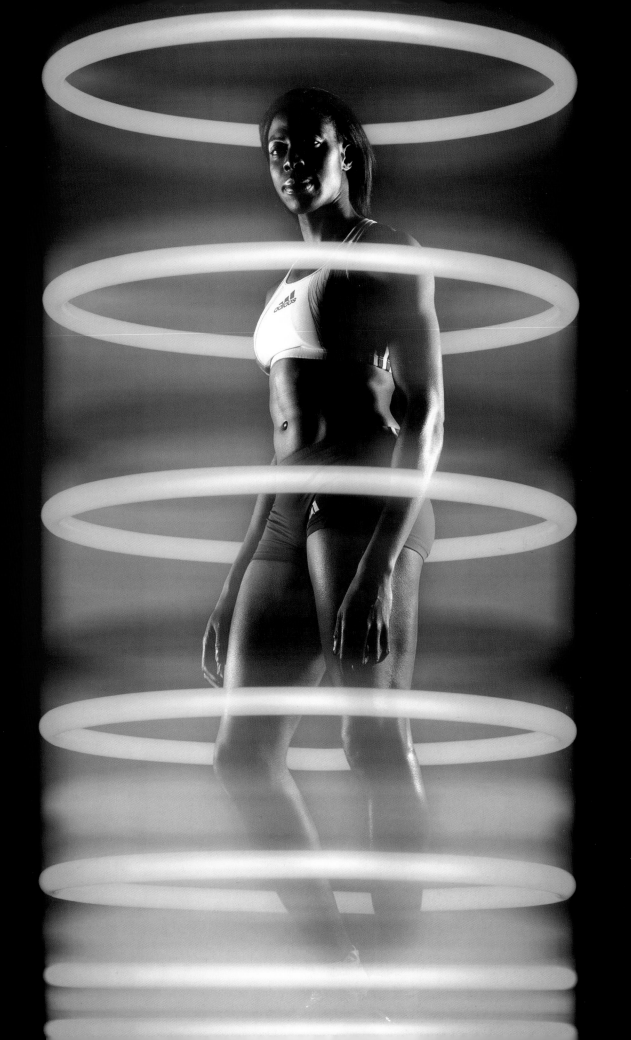

Classic Hollywood

Hollywood superstar Samuel L. Jackson was in London to promote *Snakes on a Plane*, so I arranged with his agent to meet him at a golf club on his day off to get a portrait for one of my magazine clients.

I was given 20 minutes to get my shots, which is fairly standard for photo shoots where the brief is to get three or four different setups. I decided to go for a black-and-white classic Hollywood look for this portrait and concentrate on Samuel's charismatic face. To add extra interest to the portrait I asked Samuel to bring his hands in tight to his face, which helped to frame him and create a captivating expression. I used one medium softbox positioned high above him to light his face, aimed a snoot at the background to lighten it up, and a grid backlit his face.

Eye contact

Maintaining eye contact with your subjects isn't always essential for portraits, but it can create a very strong connection between subject and audience when shooting in this style.

Samuel is well known for his intense stares, which he regularly brings to his movie roles—perhaps most famously as Jules in *Pulp Fiction*—so it made sense to capture this look in his portrait. If your subject is looking towards your camera, always focus on the eyes to ensure they're sharp and well lit.

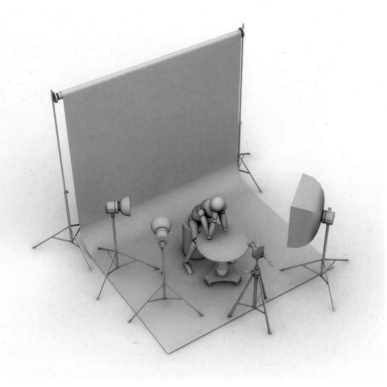

Camera	Canon EOS-1Ds Mk II
Lens	Canon EF 28–70mm f/2.8L @ 55mm
Aperture	f/8
Shutter Speed	1/250 sec
ISO	100
Lighting	Bowens Esprit

Acting up

Photographing actors and performers can be hugely enjoyable, as they are already comfortable acting and posing in front of a camera. Encourage these subjects to show off a range of expressions while you snap away to get the best shot.

James Cheadle

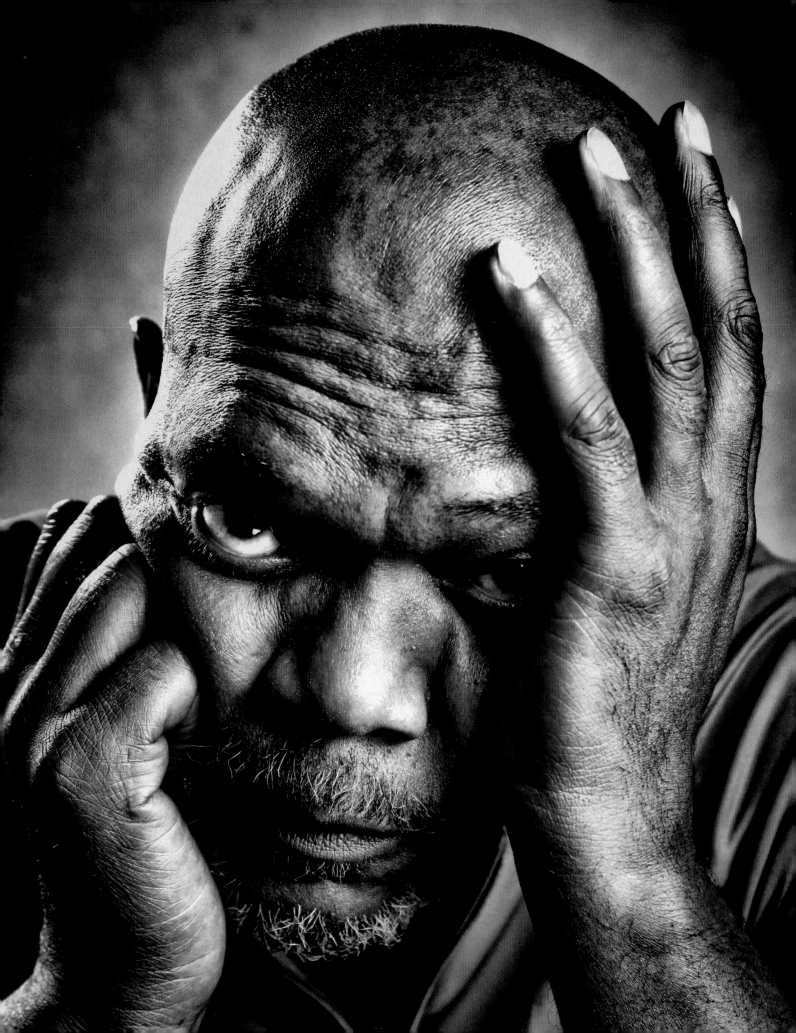

Contemporary Hollywood

Daniel Kennedy was commissioned by *The Observer* newspaper to photograph Academy Award-winning actress Angelina Jolie while she was in London at the Dorchester Hotel doing press interviews to promote *A Mighty Heart*. The hotel suites used for these press sessions are rather grand but also rather traditional, with busy wallpaper and lots of patterns—not really ideal for a contemporary-style portrait.

Kennedy needed to get a striking shot of Angelina, so as soon as he discovered the shoot was at the hotel, he reached for the 3m/10ft piece of black velvet that he keeps in the trunk of his car. Velvet soaks up light more than any other material, and it's the only way to get a true black backdrop (Colorama paper backdrops go a very dark gray, sometimes a mid-gray with light hitting them).

Quick-fire shoot

Kennedy had a precious six-minute slot with Angelina after her interview with the journalist, and the brief was to produce an arresting portrait shot for the cover of the weekend magazine accompanying *The Observer*. Prior to the shoot Kennedy set up a 3ft/1m square softbox on a Profoto Pro-7b lighting kit. He clipped the velvet to a Manfrotto Background Support System (a portable background holder), and put a chair in front of it ready for Angelina to sit on. The softbox was quite close to the right-hand side of my frame. Kennedy used a Canon EF 85mm f/1.2 lens at f/5.6 for a tight composition of Angelina's face so that he could capture her beautiful eyes and distinct facial features.

Kennedy had shot barely 12 frames when Angelina's PR agent told him his time was up. Despite the limited time, with the use of a soft light source and black background, and by converting the image to black and white, he has been able to produce a truly captivating portrait.

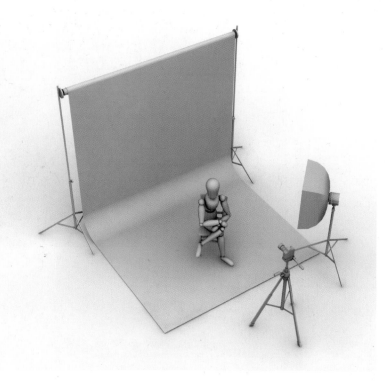

Camera	Canon EOS 5D
Lens	Canon EF 85mm f/1.2L
Aperture	f/5.6
Shutter Speed	1/125 sec
ISO	100
Lighting	Profoto Pro-7b lighting kit

Always be prepared
When photographing celebrities, pop stars, and movie stars at press junkets, be prepared to have your time cut short—you may end up with half the time you thought you had. Make every shot count, as it could well be your last.

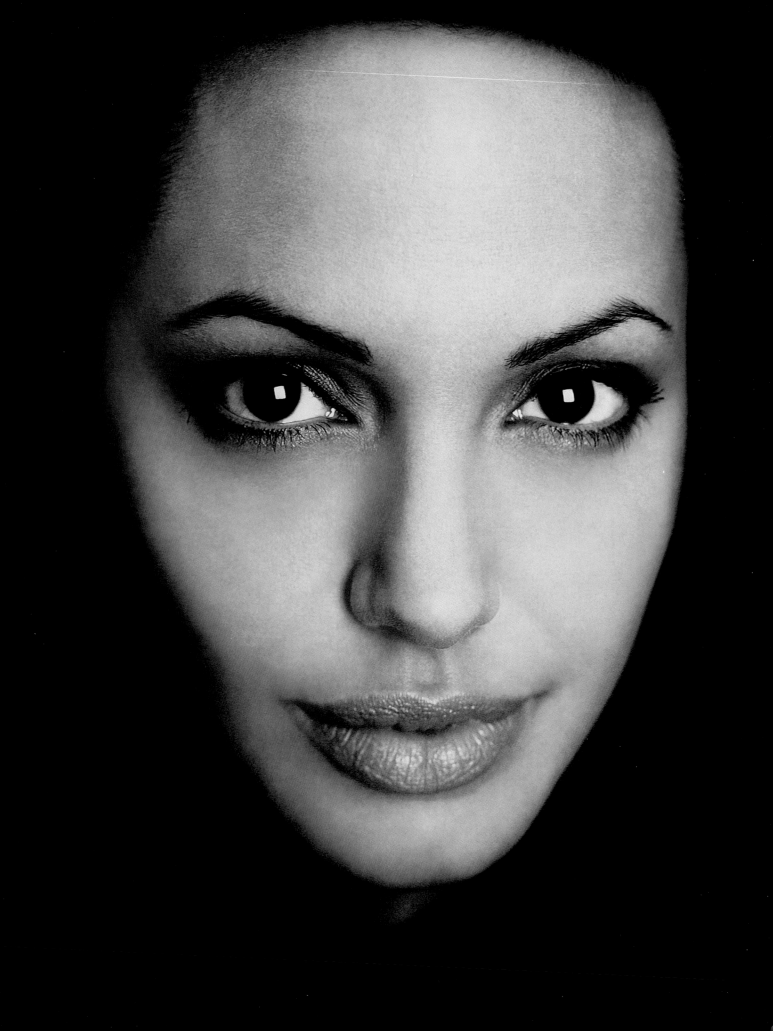

Contemporary Hollywood

Lionel Deluy photographed Matthew Perry, the actor best known for his role as Chandler Bing in the TV-sitcom *Friends*, for *emmy*, the official magazine of the Academy of Television Arts & Sciences.

Working from his studio in Venice Beach, California, Deluy had two hours to get five different portraits, and thankfully Matthew was easy going and undemanding to work with.

Whether you are working with someone famous or not, you always need to be 100% sure of yourself, and your subject needs to feel your confidence. Don't ever put yourself at a lower level than the person you are about to photograph. Place two chairs at the same height, with you seated in one and your subject in the other, and look them in the eye. Confidence is the key to every success.

Ready for your close-up?

For a long time Deluy has been using a Canon EF 100mm f/2.8 USM Macro lens. He loves to get in really close in order to add more depth to the portrait, and this lens always gives him the right frame he's looking for.

The lighting for this shot involved five Profoto light heads, which Deluy set up before Matthew arrived. Deluy always uses 7in grid reflectors with 20° grids on his Profoto heads. Deluy positioned Matthew about 10ft/3m away from a white seamless paper backdrop and aimed a 40° grid with a green gel toward it. He positioned the front light really close to Matthew and pointed it down onto his face. Deluy used a top backlight for Matthew's hair, along with two side backlights. Deluy recommends always playing with your lights until you find the right combination that suits your needs.

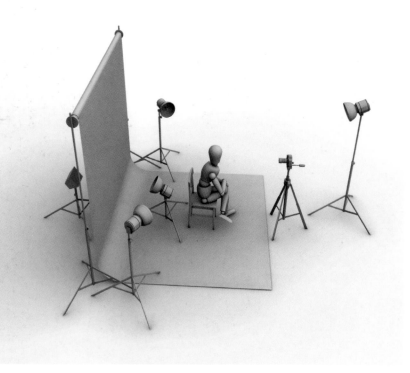

Camera	Canon EOS-1Ds Mk II
Lens	Canon EF 100mm f/2.8
Aperture	f/5.6
Shutter Speed	1/125 sec
ISO	100
Lighting	5 Profoto heads, 2 Profoto D4, green gel, 10 grids

Inspiration and ideas
Learn to get inspiration for portrait styles when you meet your subjects. Everyone has a different energy, and you need to work with this energy. The key to a perfect portrait is to try and connect with the person in front of you.

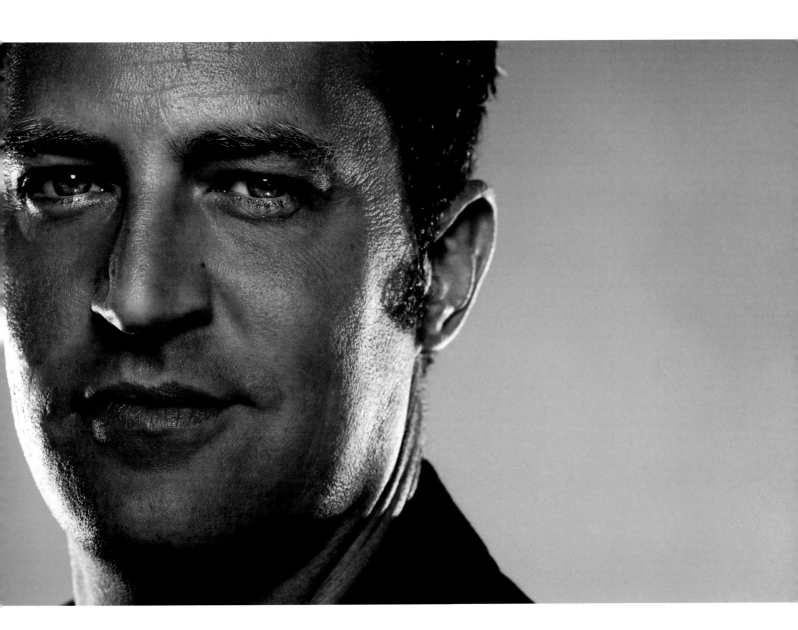

Sports

I only had 15 minutes with athlete Dwain Chambers to get a full-page portrait for *The Sunday Times*. Dwain was in the middle of a training session, and when time is tight it's essential to be able to think on your feet to get the shot. Dwain didn't want to stray too far from the track, so I used this to my advantage and got him to strike a strong pose on the starting blocks. I wanted to emphasize his muscular physique and strength of character, so I got down to his eye level and used a wide aperture of f/5.6. This enabled me to create a shallow depth of field so I could focus on Dwain's intense stare and strong upper body, while blowing the blocks and background out of focus. To direct focus on the subject, I carefully composed the shot so the lines of the racetrack angled up toward Dwain's head.

Shifting the focus

For a successful portrait it is not necessary for your subjects to look directly down your lens. For a more thoughtful feel, ask them to look off into the distance, pondering their next move. Sportspeople can be good at relaxing on camera and producing moody poses, as Dwain effectively demonstrates here.

I wanted to create a natural look for this shoot, so used a Hensel 500W head with a battery pack. This provided light from the left, using the available daylight to balance out the overall tones and prevent any harsh shadows. Although some artificial light was used, this portrait still maintains a natural feel.

Camera	Canon EOS-1Ds Mk II
Lens	Canon EF 28–70mm f/2.8L
Aperture	f/5.6
Shutter Speed	1/125 sec
ISO	100
Lighting	Hensel Porty

On the right track

It makes sense to photograph athletes in their sporting arenas. Not only are they likely to feel more comfortable in familiar surroundings—which means better expressions and better portraits for you—but it also adds context to your shots.

James Cheadle

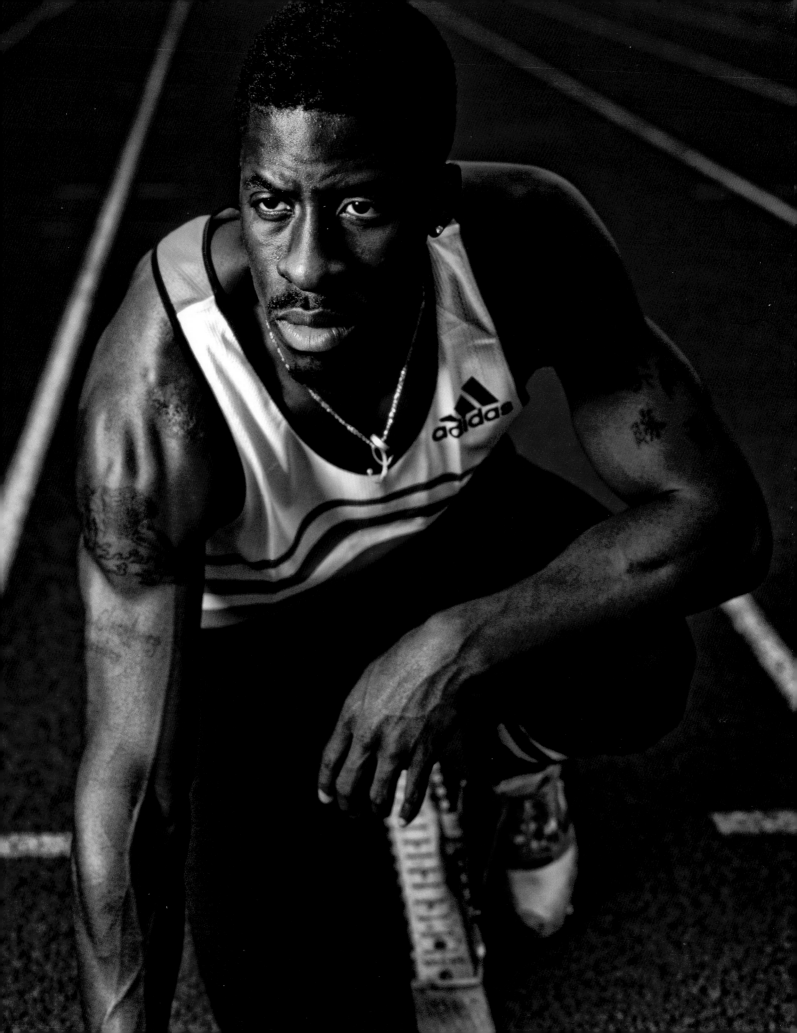

Sports

Champion French jockey Olivier Peslier had traveled to the UK to race at the Cheltenham Festival, where I shot this portrait for *Total Sport* magazine. The shoot was arranged just an hour before one of his races, so time was limited. Furthermore, Olivier's English was worse than my French, so communication was certainly a challenge.

To give the portrait an equestrian feel I decided to photograph Olivier in one of the public areas in his jockey apparel. I chose the bench to emphasize Olivier's diminutive size in a positive, fun way. Olivier was lit by one Hensel Porty light off to his right with a softbox.

Patience is a virtue

Professional photographers need the patience of a saint. To start with, it's important to be flexible when turning up for a portrait session. In my experience, sportspeople frequently change plans at short notice, for all sorts of unanticipated reasons. Olivier had a last minute meeting with his horse trainer, which meant the shoot was postponed for two hours. It's important to use this time wisely and take stock of factors like the weather, the position of the sun, locations for lighting setups, public access, etc.

For this shot the delay worked in my favor, as the crowd thinned out in the spot I'd earmarked for Olivier's portrait. This enabled me to shoot in a public area where I would have earlier struggled to find the space.

Camera	Mamiya RZ67
Lens	Mamiya 110mm f/2.8
Aperture	f/8
Shutter Speed	1/400 sec
ISO	4100
Film	Fuji Provia
Lighting	Hensel Porty

Communication breakdown

If you and your subject are unable to speak the same language, you can often direct people simply with smiles, positive body language, hand gestures, and by demonstrating yourself how you would like them to pose for the style of portrait you're after.

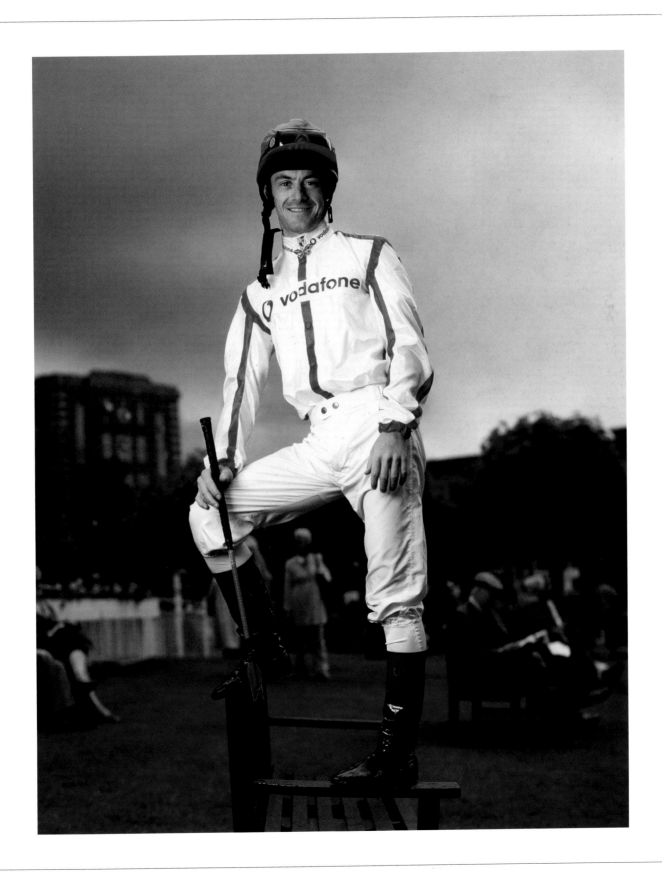

Action

I met professional rugby union player Jamie Roberts at his team's training ground on a very wet, wintry afternoon. I was commissioned by *FHM* magazine to shoot pictures for a health feature, so I needed to get a portrait of Jamie that showed him in an athletic pose.

The great thing about working with many professional rugby players is that they rarely complain about the cold weather. Jamie posed and played around in front of my camera in near freezing temperatures for 20 minutes without complaint—even though he'd just finished a grueling three-hour training session.

Prefocusing

In order to inject some action into this portrait I asked Jamie to lunge at my camera as if he were handing off an opposition player. This kind of action shot requires planning to get it right. I asked Jamie to fix his starting and finishing point so I could manually prefocus on his eyes to ensure the final image was pin-sharp in all of the right places. This method of manual focusing is useful for all kinds of action portraits when your DSLR's autofocus tracking mode isn't an option due to erratic movement.

I lit Jamie using a two-head Elinchrom Ranger Quadra AS system with one light above Jamie's head, which produced a strong moody effect, and another backlighting him. This lighting setup also created an outline around Jamie's hand in the foreground, which helped it stand out.

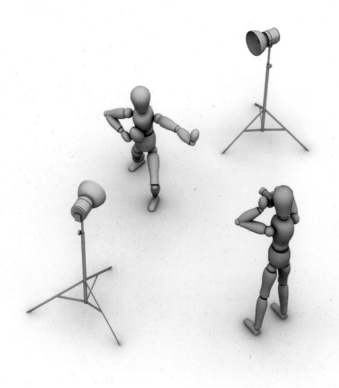

Camera	Canon EOS-1Ds Mk III
Lens	Canon EF 24–105mm f/4L IS @ 32mm
Aperture	f/9
Shutter Speed	1/125 sec
ISO	160
Lighting	Elinchrom Ranger Quadra

Emphasizing the action
Use a slower than normal shutter speed in order to capture the movement of your subjects. Choosing the shutter speed will depend on how fast your subject is moving, how much motion blur you want, and your lighting source. A good starting point is around 1/60–1/80 sec, then work up or down from there.

Action

Adventure park Go Ape asked me to shoot a range of publicity shots that incorporated action, fun, and adventure.

This portrait, taken on the commando slide, was particularly challenging, as the model—through no fault of her own—kept spinning around on the rope. It wasn't until the twelfth attempt of sliding down that she was in the right place at the right time, and facing in the right direction, for me to get my shots.

Choosing the right focus mode

Most modern DSLRs are equipped with a choice of autofocus (AF) modes. I use a professional Canon DSLR, which has an AI Servo AF mode for photographing moving targets. This mode enables you to target your chosen AF point on your action subject and then, by depressing the shutter button half way, you can "follow focus" and keep your subject sharp while taking shots at will. The majority of DSLRs will also enable you to manually set your AF point to allow you to position your subjects wherever you want in the frame to suit your composition.

I simply used the available daylight for this action image and shot using the Tv (Time value or shutter priority) mode. This meant I could fix my shutter speed at 1/640 sec while my DSLR automatically adjusted my aperture for a correct exposure as the model moved through the shade and sunlight high up in the trees. I also upped the ISO to 250 so my shutter speed was fast enough to freeze the action.

Camera	Canon EOS-1Ds Mk III
Lens	Canon EF 300mm f/2.8L IS
Aperture	f/2.8
Shutter Speed	1/640 sec
ISO	250
Lighting	Available light

Telephoto prime lenses

Telephoto prime (or fixed focal length) lenses are often considered the best quality as they have the best glass, fastest and most accurate autofocusing, and not as many moving parts as zoom lenses, which can compromise image quality. If you don't want to spend lots of money on expensive professional telephoto lenses, rent one for specialist shoots instead.

Weddings

When it comes to shooting weddings, the weather can determine what you can and cannot do. However, Brett Harkness made sure this wasn't the case when photographing this wedding in Canada—even torrential rain didn't stop him from getting the portraits he needed.

For this shot, Harkness found a great purple barn in a wheat field near the wedding venue. It had a 3ft/1m overhang, which was great for keeping the happy couple dry, while Harkness and his assistant got soaking wet! The wheat field reflected a certain amount of light and the assistant also directed light on to the bride and groom with a TriGrip Lastolite reflector. Using a medium ISO of 400 gave a shutter speed of 1/320 sec at an aperture of f/6.3 to work with, which was perfect. Composing the shot with lots of room around the couple meant Harkness was able to incorporate some beautiful color into the image on an otherwise very dark and dull day!

Contemporary wedding photography

It's important to remember that wedding shoots are all about the bride and groom, not the photographer. Clients hire you because you are able to produce beautiful images at any venue and in any weather condition, and because you can work fast and won't disrupt their big day too much. Learn to work with your couple, and remember that not everyone is out for a fashion shoot. Make it comfortable, relaxed, and, most of all, real.

Harkness has always found that if he's excited, this energy rubs off on the bride and groom, which means better wedding portraits and happy clients!

Camera	Canon EOS-1Ds Mk III
Lens	Canon EF 70–200mm f/2.8L IS USM @ 90mm
Aperture	f/6.3
Shutter Speed	1/320 sec
ISO	400
Film	Ilford HP5
Lighting	Available light and Lastolite reflector

RAW power
When using DSLRs, it's good practice to always shoot in RAW—the highest image quality setting. This gives you greater control in Adobe Camera Raw (the RAW image processing software that comes with Photoshop CS) if you need to make adjustments to your files.

Brett Harkness

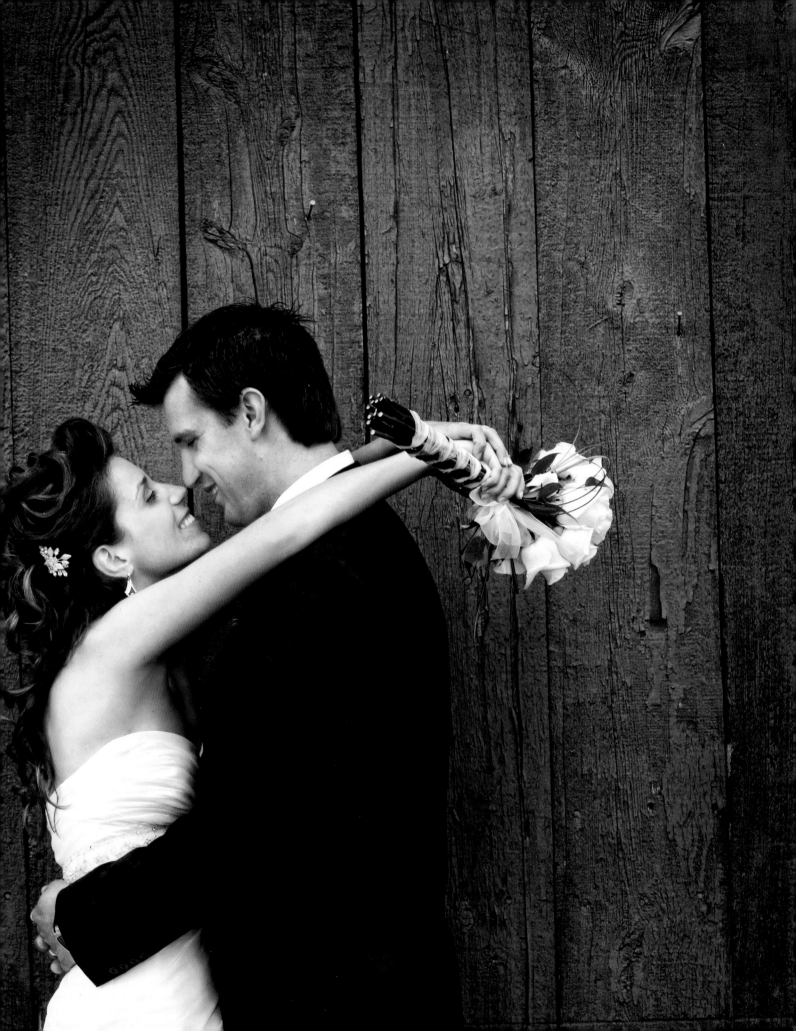

Corporate

I was commissioned by international accountancy firm Deloitte to take a series of corporate portraits to be used as part of their rebranding materials. As with any rebranding initiatives there were strict guidelines, and for these images I was asked to capture informal poses against clean white backgrounds.

These portraits were intended for national and international marketing literature, and were also blown up to 118in/300cm-wide prints to be hung above their main reception desk, so my shots had to be well lit and perfectly exposed.

Four-light setup

When shooting with white backdrops it's important to ensure your lighting is even over the entire frame, in order to prevent any unwanted shadows and inconsistencies. To get around this issue I used a four-head setup for this portrait, with two lights on the subjects and another two on the background.

To compose the portrait I asked the two subjects to sit in a staggered position in order to help add depth to the shot, and kept both facing into the frame to draw attention into the center of the image. I used the long end of a telephoto zoom lens (at a focal length of 140mm) to compress the image so that the lady in the foreground is the main focus.

Camera	Canon EOS-1Ds Mk II
Lens	Canon EF 70–200mm f/2.8L IS @ 140mm
Aperture	f/13
Shutter Speed	1/200 sec
ISO	160
Lighting	Bowens Esprit

Whiter than white

To ensure the backdrop of your portrait is pure white, use your own portable backdrop roll. You can also use Photoshop to correct any off-white backgrounds with the Set White Point Eyedropper tool, found in the Levels dialog box.

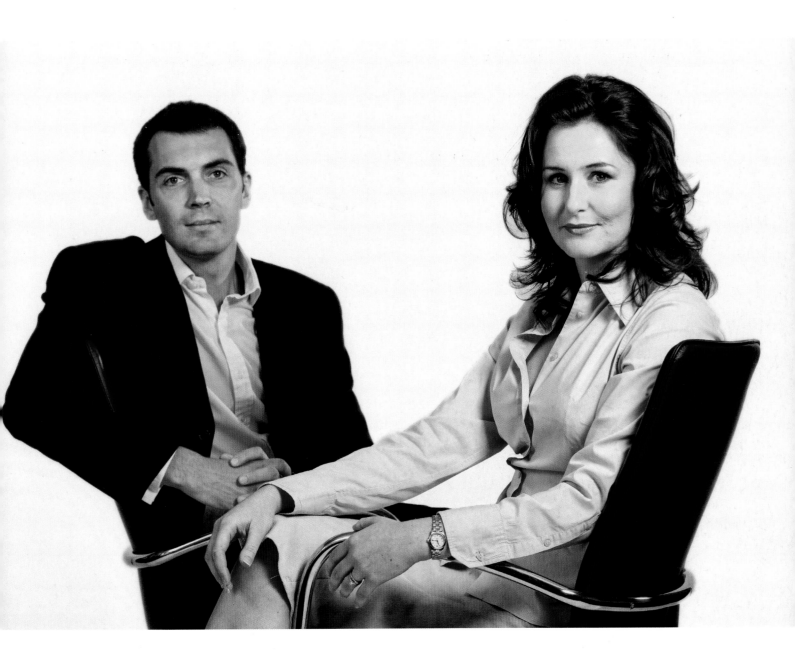

Workplace

Douglas Levere shot this portrait for *The American Lawyer* magazine to accompany a story on the Federal COPS (Community Oriented Policing Services) and how it was working to help fight crime in small towns across the USA. As part of the assignment Levere was sent to Oklahoma to photograph Muskogee County Sheriff, Clifford Sinyard.

He flew out to Oklahoma and met Clifford late in the afternoon. As Levere didn't want to fly 1,500 miles to photograph the subject in an office, they drove around in Clifford's truck to check out three different locations. What Levere hadn't envisaged was that the locations would be so far apart. They had been driving for two hours (which for Clifford was "just down the road"), while Levere anxiously watched the daylight levels drop on this overcast afternoon. When they finally got to this location on a cattle farm, they had almost run out of daylight.

Old school

Levere used his old Kodak 4x5 Monorail film camera with a Schneider APO-Symmar 150mm f/5.6 lens. By moving the front of the camera (or the lens plane) independently to the rear that holds the film, he altered the depth of field. The front standard was almost fully tilted back toward Levere, which narrowed the focal plane and intentionally caused the falloff in the bottom corners of this portrait.

He lit Clifford with a Comet PMT with one head, and a medium Photek SL-5000 umbrella without a cover. By now it was getting dark, so he ended up shooting at a slower than desirable, but still workable, shutter speed of 1/8 sec.

Camera	Kodak 4×5 Monorail
Lens	Schneider APO-Symmar 150mm f/5.6
Aperture	f/8
Shutter Speed	1/8 sec
Film	Kodak Portra 160VC color film
Lighting	Comet PMT with one head and a medium Photek SL-5000 umbrella

Location, location, location
Knowing the area you're about to shoot in isn't always possible, but if it's likely to be dark by the time you reach your location, rather than losing a battle against the daylight, stay on set and get creative with your compositions, poses, and lighting setups to capture a different range of portraits for your client.

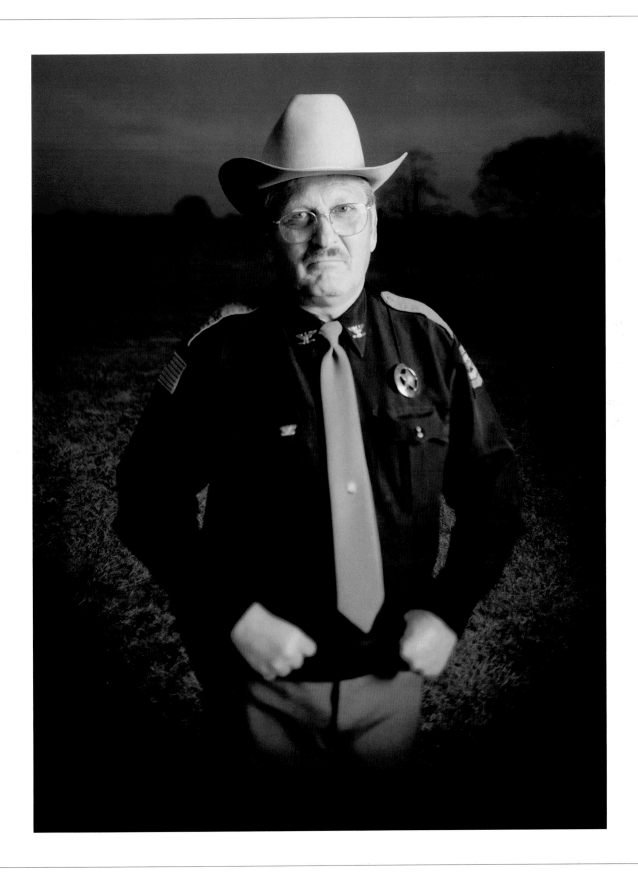

Group Shots

Loaded magazine commissioned me to fly to Philadelphia to cover the annual Army-Navy American college football match. The brief asked for lots of atmospheric shots of the Army and Navy fans, so I walked around the impressive Lincoln Financial Field stadium looking for opportunities.

The match was in the third quarter with the Navy trailing by just three points, so the energy in the ground was incredible. The sailors in this shot didn't need much encouragement to show me the passion I needed in order to make this group photo work.

Arranging the group

With any group shot it's important to get your composition right. I always try to add depth to group shots by creating foreground and background interest. Creating a tiered composition with some of the sailors at the back of the ground stood on their chairs and others at the front sat down meant that everyone was visible in the foreground, and you can still see the all-important match and stadium in the background.

For this shot I wanted to capture the energy and excitement of the group. With so much action happening on the field they needed little prompting to give me the reaction I required to make this shot work.

To light the group I synchronized my camera using a Canon Speedlite Transmitter ST-E2 and then held my Canon Speedlite flash unit off-camera and to the left of the frame.

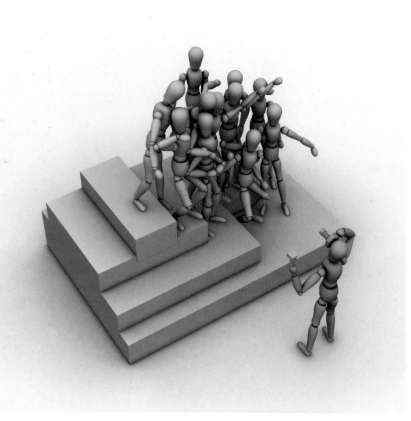

Camera	Canon EOS-1Ds Mk II
Lens	Canon EF 16–35mm f/2.8L @ 18mm
Aperture	f/2.8
Shutter Speed	1/200 sec
ISO	200
Lighting	Canon Speedlite 580 EX II flash unit and Canon Speedlite Transmitter ST-E2

Group shot lens choice
Use a wide-angle lens (16–35mm) for big group shots so that you're able to fit everybody in the frame. This is especially important when space is limited and there isn't much room to stand back from your subjects. Beware if your DSLR has a 1.5x or 1.6x crop factor, as the effective focal length of your wide-angle lens won't be as wide.

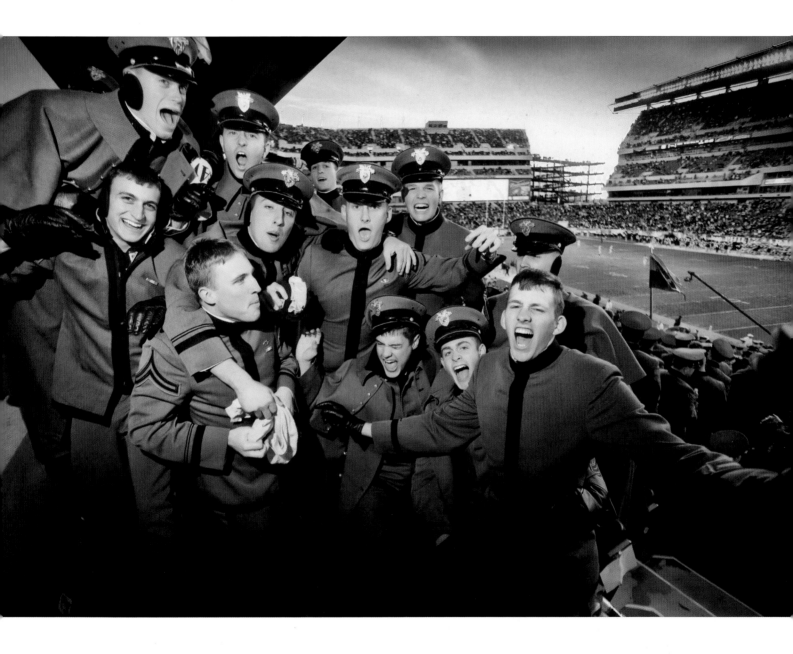

Group Shots

These cyclists (and their cunning two-wheeled contraptions) had just competed in a Human Powered Vehicle race. My client Mazda asked me to get a group shot of the top riders that summed up the day.

I was lucky with the weather, so I decided to take full advantage of the sky and lie on my stomach during this shoot so I could get as much blue sky in the frame as possible. The subjects were backlit by the sun and I used two Hensel Porty battery-powered lights to light the three cyclists from the front.

Keeping the background clean

Group shots can become very messy when there's a lot to fit in the frame, so whenever possible it's sensible to use an uncluttered background so that all of the focus falls on the subjects. This can be achieved by shooting against blank walls, using height to get above your subject and shooting down, or, as in this shot, getting down low and shooting upward to include more blue sky as a backdrop.

I had to lie on my stomach in order to make full use of the clean sky as the main background in this shot and to ensure minimal greenery appeared in the middle of the frame. To add depth I used a 16–35mm wide-angle lens at a focal length of 23mm. I positioned the first cyclist on the left and in the foreground and staggered the other two cyclists to the right to avoid a flat, uninteresting group shot.

Camera	Canon EOS-1Ds Mk II
Lens	Canon EF 16–35mm f/2.8L @ 23mm
Aperture	f/16
Shutter Speed	1/250 sec
ISO	100
Film	Ilford HP5
Lighting	Hensel Porty

Neutral density filters
Although graduated neutral density filters are predominantly used by landscape photographers, they are also invaluable to portrait photographers when turning lifeless, gray, or bright white skies into dark and moody backdrops.

James Cheadle

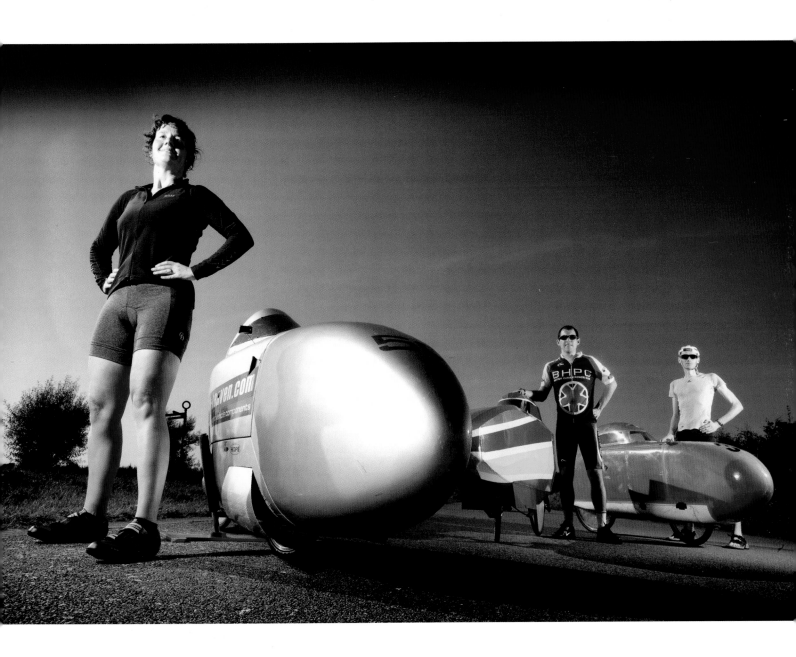

High Saturation

Today's Golfer magazine commissioned me to photograph actor and fanatical golfer Damian Lewis, best known for his lead television roles in *Band of Brothers* and *Life*.

It was a beautiful summer's day and the shoot was held at a country club. The colors of the sky and grass really jumped out at me, so I decided to go for a high saturation look for this portrait. This style also really suited the deep tan colors of Damian's hat and sunglasses. The very simple composition was necessary due to the small amount of time Damian had, so making use of rich colors was a good, quick solution.

Shooting in a hurry

Every so often you'll have to shoot a portrait in a very short amount of time, so it's an essential skill of any professional photographer to have a selection of well-practiced styles in mind to cope with these challenging circumstances. These scenarios often crop up when shooting celebrities like Damian due to their hectic schedules.

I initially had 45 minutes set aside for this portrait session, but Damian got stuck in traffic so the shoot was cut to 10 minutes. Due to the time restriction I immediately went for a tried-and-tested setup I'd used in the past—a slightly side-on, side-lit headshot—a style I always know will produce a good result. I'd also just been to the same location so knew immediately where to position Damian to save time. This shot is lit with one Hensel Porty light positioned off to Damian's left at 45 degrees. To take full advantage of the rich colors, I subtly boosted the saturation in Photoshop with the Hue/Saturation command.

Camera	Canon EOS-1Ds Mk III
Lens	Canon EF 70–200mm f/2.8L IS @155mm
Aperture	f/10
Shutter Speed	1/250 sec
ISO	100
Lighting	Hensel Porty

Saturation point
To take full advantage of the rich colors in portraits such as these, it's a good idea to also subtly boost the saturation in Photoshop using the Hue/Saturation command.

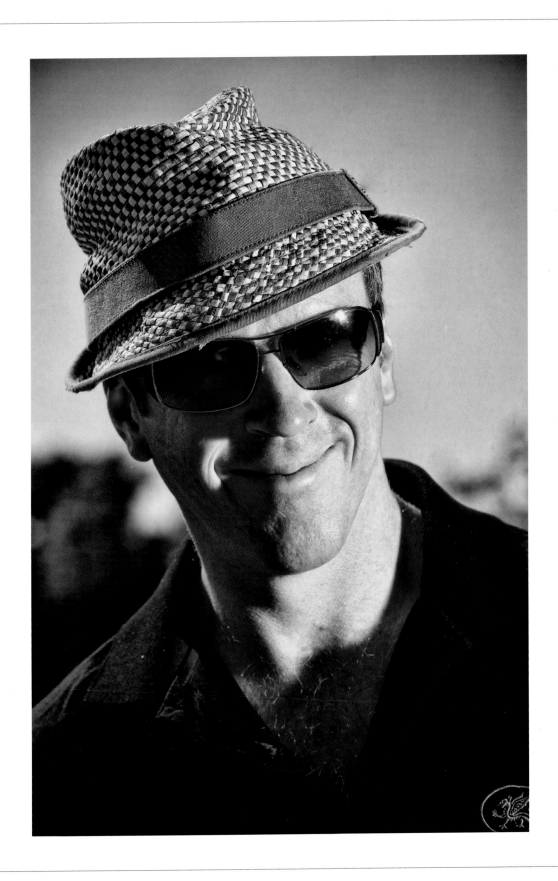

High Saturation

I was commissioned by *Guitarist* magazine to photograph prolific guitarist Dominic Miller. Dominic is best known for his work with Sting, but he is also an established and successful solo artist and has worked with many other big-name bands.

This portrait was shot at Dominic's country home, so I opted to use an old building as a backdrop. The rich color of the red brick wall contrasted well with the rustic green window frame and old wooden door. The shot was lit with a single battery-powered Hensel Porty head placed off to Dominic's right.

Using lights in daylight

I'm often asked why there is a need to use lights when shooting outdoors, and my response is that you can never have enough options when it comes to setting up a quality portrait.

I never leave home without a set of lights—for both indoor and outdoor shoots—as they enable me to be in total control of the lighting situation. The problem with relying on available light is that you don't have any control over the shadows or direction, power, and consistency of the light. Available light can sometimes give you perfect results, but you can never fully rely on it. Lights are essential tools for any professional photographer, and if you take lights to every shoot you can guarantee professional results every time.

Camera	Mamiya RZ67
Lens	Mamiya 110mm f/2.8
Aperture	f/5.6
Shutter Speed	1/250 sec
ISO	100
Film	Fuji Provia
Lighting	Hensel Porty

Photography with passion
If you don't care about your photos then nobody else will either. This is why it's important to remain passionate about the portrait shots you take. If you're just going through the motions to get a shot it will show in your lackluster results.

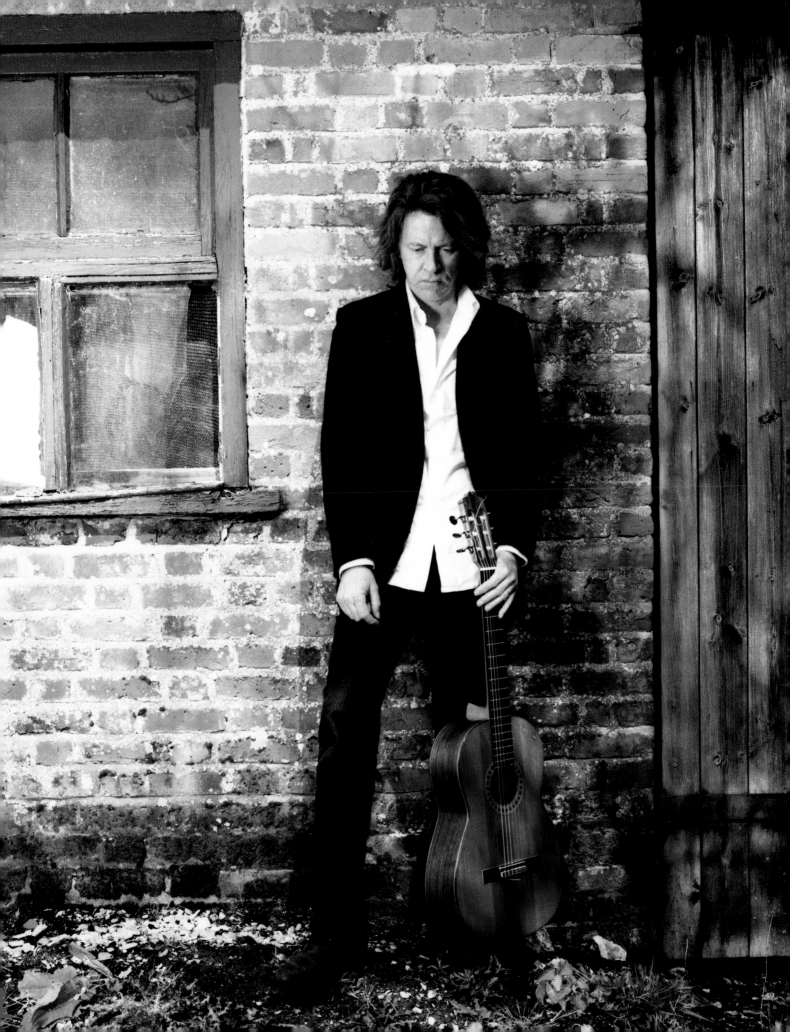

Families

I photographed this family portrait one evening toward the end of the summer. We found these great hay bales in a local field, so I asked the family to climb up and sit on top of a bale, huddling together to create an interesting pose.

The sun was just beginning to drop so time was limited. To take full advantage of the beautiful fading sky I had to use a couple of portable studio lights to illuminate the family. I used a lightweight set of battery-powered Elinchrom Ranger Quadra heads—one positioned to the left of the frame and the second placed just off to the back right to backlight the family.

The right time of day

When shooting outdoors on a sunny summer's day you will always find the best light in the early morning or early evening. During this time the sun is lower in the sky, which means softer and more flattering light for portraits.

The magic ingredient that really makes this shot stand out is the lovely dusk light in the sky. The shot wouldn't have had the same feel if it was taken at midday, as the sun would have produced top-heavy light, resulting in shadows directly falling on the family.

Camera	Canon EOS-1Ds Mk III
Lens	Canon EF 24–105mm f/4L IS @ 58mm
Aperture	f/10
Shutter Speed	1/100 sec
ISO	160
Lighting	Elinchrom Ranger Quadra

On-camera filters
Filters attached to the lens of your DSLR can produce dramatic effects that will greatly enhance an otherwise flat portrait. Try using a circular polarizer filter to boost the contrast and intensity of midday blue skies peppered with white clouds.

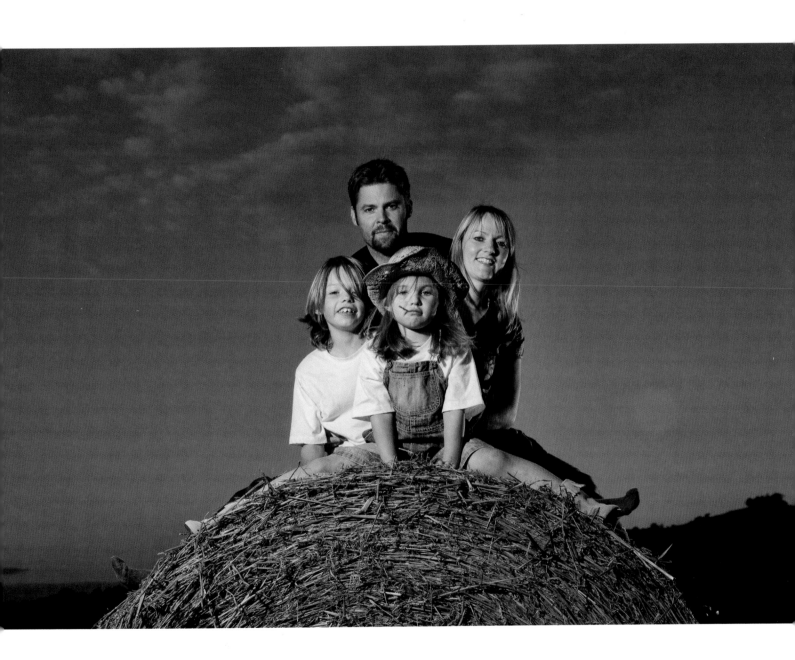

Children

Working with children can be both challenging and rewarding. Fortunately, these choirboys from Gloucester Cathedral were perfect models for this BBC photo shoot, intended as a cover image for the Christmas edition of *BBC Music Magazine*.

I wanted a shot of the boys walking along a cloister inside the cathedral, but there was very little natural light coming in. To keep my shot sharp, the boys had to walk toward me at an unnaturally slow pace to prevent any motion blur. I wanted to use a shutter speed fast enough to keep the boys sharp but slow enough to be able to retain detail in the beautiful cloisters behind.

Directing your shoots

It's important when working with children to give concise direction and explain clearly the type of shots you want to get, but above all, it's essential to let the children enjoy themselves. If your subjects are happy you'll have a much more productive shoot, so it's helpful to involve your subjects and keep it fun. For this shot I encouraged the boys to act natural and chat as they walked.

I lit the boys with one Elinchrom Ranger Quadra head, just out of shot on the right-hand side of the frame. The natural light from the left came from a window.

Camera	Canon EOS-1Ds Mk III
Lens	Canon EF 70–200 f/2.8L IS @ 90mm
Aperture	f/2.8
Shutter Speed	1/60 sec
ISO	250
Lighting	Elinchrom Ranger Quadra

Crucial copyright

When photographing children, it's imperative that you obtain a signed permission from their parents first. Whether you are able to reuse their child's portrait (for editorial or advertising purposes, for instance), will vary—some parents (and children) will be flattered, and some will be strongly against their photos appearing publicly. Either way, get parents to sign a copyright agreement form on the day of the shoot.

James Cheadle

Children

This portrait was taken specifically for a stock library. The little boy's mother, who has produced photo shoots for many years, told Daniel Milnor about the location and arranged for the little girl to also be in the photo. The house, located in Malibu, California, was owned by a friend of hers, which meant they could work unobstructed.

The idea for the portrait was to create a picnic scene and let the kids behave naturally. When it comes to photographing children Milnor always tries to act like a big kid, which usually gets a good response, as was the case with this shot.

Back to basics

Milnor only uses natural light when photographing these days. A long time ago he realized that whenever he was using lighting and strobes (flashguns), he was always trying to make it look like natural light anyway, so he simply learned more about natural light and how to make it work. Milnor sold his strobes about ten years ago and hasn't ever felt like he's needed to use them since. For this shot, the outdoor lighting worked to his advantage, with the sunlight diffused nicely through the trees.

Milnor has used digital cameras for years, but still loves film far, far more. He feels that it makes him a tighter photographer and helps him to focus better. He shot this portrait with a Canon EOS-1V film SLR and a 135mm f/2L prime lens, as he prefers to capture a shallow depth of field. For him, out-of-critical focus areas captured with film are so beautiful—a sea of texture and color.

Camera	Canon EOS-1V
Lens	Canon EF 135mm f/2L USM
Aperture	f/2.8
Shutter Speed	1/250 sec
ISO	160
Film	Kodak Portra Vivid Color
Lighting	Diffused natural light

Child's play

The younger your subjects, the shorter their attention span will be. Bear this in mind when photographing children, and be efficient with your shots, as bored facial expressions do not make good portraits.

Babies

I took this portrait of baby Molly just after she had woken up, so she was still a little confused as to what was going on around her. This worked in my favor though, as her slightly surprised facial expression peering out from under her hood really makes the shot work. I always like to make the eyes the main focus in baby portraits, as they are so big and striking.

Rather than using artificial light or wasting time with a studio setup, I opted to utilize available light from the window to Molly's right. This helped create a smooth, natural feel and avoided any overly harsh shadows.

Rattles and cuddly toys

Photographing babies is all about interaction. You really have to know how to make those funny "goo goo ga ga" noises when taking baby portraits as normal communication isn't an option. As well as learning to speak "baby" you can also make the most of the baby's favorite toys to entice a response that you can capture on camera.

A great technique I use is to get one of the baby's parents to stand right over my shoulder and smile and laugh or use a small toy to get the baby's attention. Keeping a parent close by is essential to make sure the baby feels comfortable and secure.

Camera	Canon EOS-1Ds Mk II
Lens	Canon EF 50mm f/2.5
Aperture	f/2.5
Shutter Speed	1/60 sec
ISO	400
Lighting	Window light

Baby face

There is usually only a short window of opportunity to photograph babies—in between feeding and sleeping. Ask your clients to make sure they've just fed and changed their babies so you're both not wasting valuable studio time.

Low Light

This low-light portrait was taken at night in a client's living room, with just one table light for illumination. I wanted to give the portrait a candid, relaxed feel, so I opted to photograph the girl without flash light. To get the desired effect I turned off all the lights in the room apart from one small table light, which side lit the girl.

The great thing about shooting digital is that the yellow color household lightbulbs create is easy to correct with image editing software (adjust the White Balance/Temperature sliders in Adobe Camera Raw). This also enables you to travel light and still create stunning images, especially when you're dealing with children who won't sit still, or feel uncomfortable, in front of your studio lights.

High ISO solutions

Photographers who cut their teeth using film will be used to keeping to ISO 100, which is understandable when you take into account the boundaries that film imposes on you. However, recent revolutions in high-ISO Canon and Nikon pro DSLRs mean it is now possible to shoot striking portraits in low-light situations that would have been impossible a few years ago. With these professional DSLRs it's possible to achieve impressive results at ISO 3200 and 6400 with little noise pollution.

Camera	Canon EOS-1D Mk IV
Lens	Canon EF 85mm f/1.2L II USM
Aperture	f/2
Shutter Speed	1/125 sec
ISO	6400
Lighting	Table lamp

Pushing the boundaries
Don't be scared of pushing your camera to its limits, especially when shooting without flash at high ISO settings in challenging low light conditions. Always get to know the capabilities of your equipment and never be afraid to experiment with new techniques.

James Cheadle

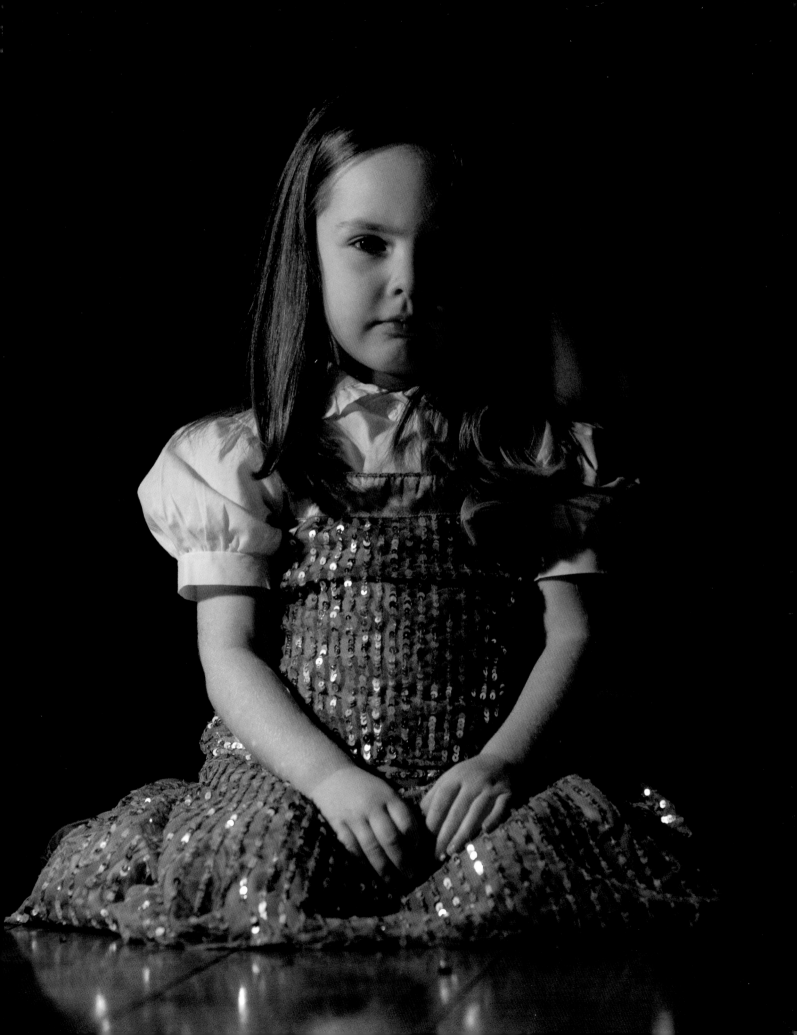

Available Light

Keeping your lights firmly locked away in their cases and shooting in available light can be a liberating experience, opening up a whole new way of approaching portrait photography.

I was commissioned by the Discovery Channel to take portraits of king crab fishermen in Seattle to promote their television show *Deadliest Catch*. Captain Johnathan Hillstrand was one of the lead characters in the show and wanted to be photographed drinking in a local bar. This suited the brief, which was to capture the fishermen in their natural environments. To take this shot, I simply used the available light spilling in from the street outside to light him as he turned to look down my lens.

Upping the ISO

A good rule to stick to when shooting portraits is to keep the ISO sensitivity as low as possible (e.g., ISO 100) to achieve the best quality images with minimal grain, but as with most rules there are exceptions. When shooting portraits indoors or in low light you'll often need to up the ISO sensitivity on your DSLR to let enough light into your frame to make the shot work. Upping the ISO will also mean you can achieve a faster shutter speed, so camera shake will be less likely to cause blurred portraits. Increasing the ISO can mean more grain, but this grittiness can sometimes enhance the feel of your portraits.

Camera	Canon EOS-1Ds Mk II
Lens	Canon EF 28–70mm f/2.8L @ 28mm
Aperture	f/2.8
Shutter Speed	1/80 sec
ISO	400
Lighting	Available light

ISO performance
Depending on your DSLR, high ISO performance and noise levels will vary at ISO 400, 800, 1600, and 3200. With your camera on a tripod, and using only available light, take test portraits indoors at each ISO setting from 100 to 3200 to see how far you can push the ISO before image quality diminishes.

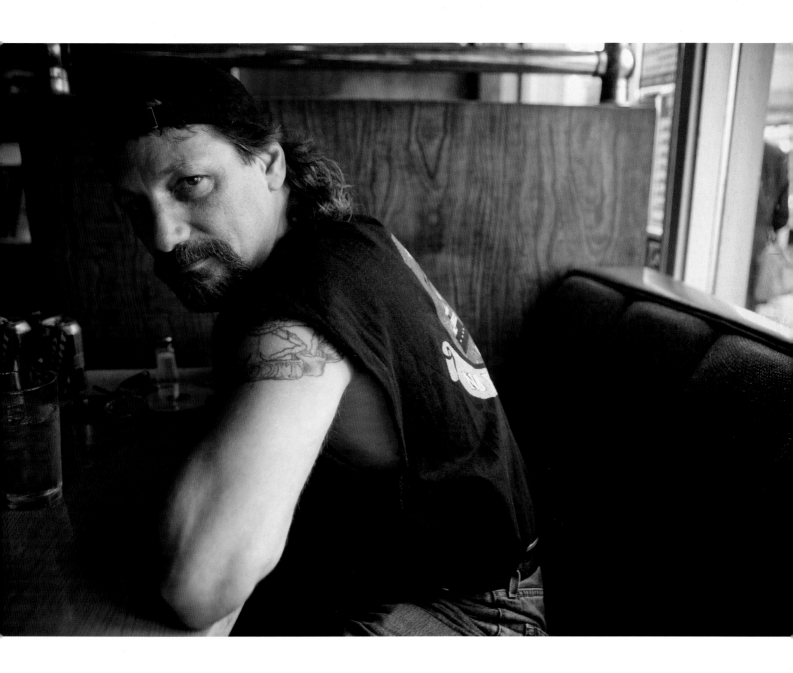

Ring Flash

This portrait was taken for the Art Center in South Florida, as part of a photography project tilted *Miami Night Life*. Ben Brain was one of ten photographers invited to explore the theme. He wanted to take a closer, almost forensic, look at the diversity of characters cruising Washington Avenue at night. Unlike many shoots in Miami, there were no models involved. At first it was a little intimidating approaching total strangers on the streets at night, however nearly everyone he approached was willing to have their portrait taken, and his confidence soon grew.

Ring of fire

Because Brain had decided to use a macro lens and a big ring flash, he was forced to work in very close proximity with his subjects. There was nothing discreet or candid about what I was doing; it almost felt confrontational shoving such a large camera and ring flash in each person's face.

He photographed about 20 different people all from the same distance. In this instance, he wanted the subject's face to fill the frame so that every detail would be revealed. Using manual mode, Brain worked out his exposure and flash settings before starting the shoot so that he didn't waste time fiddling with meter readings and exposure settings. The combination of ring flash, macro lens, and medium format camera created super-sharp, highly detailed portraits—exactly what he was after. He was particularly pleased with the circular catchlight captured in the subject's eyes from using a ring flash.

Camera	Mamiya Pro 645
Lens	Mamiya MF 120mm f/4 Macro lens
Aperture	f/16
Shutter Speed	1/60 sec
ISO	100
Lighting	Sunpak ring flash

Experiment with confidence
Working on photographic projects is a great way to master new portrait techniques and to strengthen your portfolio. When your working schedule isn't packed, use this time wisely to learn a new portrait style.

Travel

When I'm traveling I always carry an off-camera flash with me and have my camera at hand, ready to fire, because you never know what photo ops are going to present themselves. This portrait is a classic example. It was taken in Macha in the Bolivian Andes, and the couple were attending the annual Tinku festival, a ritual combat made in worship of Pachamama (mother earth). It took me seconds to keep this wonderfully charismatic couple's attention while I attached my flash cable and took the shot, with some fill light really accentuating their facial lines.

Fill flash

When shooting with fill flash it's important to set your exposure for the background to avoid overly dark/bright backdrops or under/overexposed skies. My shutter speed was set at 1/200 sec for the flash, and because it was a bright day I needed an aperture of f/13 to correctly expose for the background and dramatic sky.

Compositionally, I got down low so I could shoot up toward the couple and fit more of the amazingly moody sky full of dark clouds in the frame. If the sky had been bright blue and clear this shot wouldn't have a slightly menacing feel, which is what helps to make this such a powerful portrait.

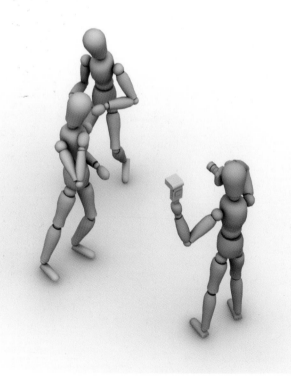

Camera	Canon EOS-1Ds Mk II
Lens	Canon EF 17–40mm f/4L USM lens
Aperture	f/13
Shutter Speed	1/200 sec
ISO	125
Lighting	Canon Speedlite 580 EX II flash unit

Seize the moment
It's all about grabbing chances while you can when it comes to travel portraiture. Spotting characters that will make great portraits, and then interacting quickly to capture natural poses, will make all the difference to your results.

Travel

I was in Morocco on a shoot for Triumph motorcycles and needed to take some travel portraits that captured the local ambience for their brochures. Snakes have never been my favorite creatures but I was keen to get a good portrait of this snake charmer in Marrakech's Djemaa el-Fna market square, so I used a telephoto zoom lens from a safe distance!

An often-encountered problem when shooting in foreign countries is communication. This performer spoke Arabic and a smattering of French, which I only speak at a basic level, so directing him was easier said than done. I eventually managed to explain to him that I needed him to move toward the pool of sunlight that was bursting through the Koutoubia Mosque across the square in order to take the shot.

Capturing the local flavor

When shooting travel portraits it's important to capture the local flavor to give the viewer enough information to imagine the location without necessarily including everything in the shot. A great way of achieving this is to choose a background or prop that is indicative of the foreign setting.

Waiting for the right light is also an effective way of instilling the right mood in your portraits. I waited until early evening to get this shot, as it is the buzz of evening that makes this market square in Marrakech so well known to visitors.

Camera	Canon EOS-1Ds Mk II
Lens	Canon EF 70–200mm f/2.8L IS @155mm
Aperture	f/2.8
Shutter Speed	1/250 sec
ISO	100
Lighting	Available light

People and places

When photographing portraits you only need to include a suggestion of your location in the background or foreground, not the entire scene, otherwise your shots become more about the place than the people.

Low Saturation

In the same way that some portraits lend themselves to a high-saturation style, others look great with the more muted tones of a low-saturation portrait. A perfect example is this shot of former boxing world champion Joe Calzaghe CBE, MBE, taken at his local gym.

The first thing that struck me when I entered the gym was how the then super middleweight world champion trained in such simple facilities. There was very little light in the gym, which is partly why I went for a low-saturation portrait style, using one softbox mounted on a Bowens Esprit head.

Allowing for bright colors

The dark tones in the gym helped enhance the feel I was trying to create in this portrait. I was looking to capture a very simple, moody portrait of Joe, but I was faced with the problem of the bright red punching bag and boxing glove dominating the frame and drawing attention away from Joe. The solution was to shoot a low-saturation portrait and do some minor Photoshop work afterward using the Hue/Saturation command. This helped to desaturate and strip away some brightness from the otherwise distracting punching bag and boxing glove.

Camera	Mamiya RZ67
Lens	Mamiya 110mm f/2.8
Aperture	f/2.8
Shutter Speed	1/60 sec
ISO	200 (100 pushed a stop)
Film	Fuji Provia
Lighting	Bowens Esprit

Capturing the mood

If you're photographing big names (whether they are sports stars, musicians, actors or business people), do your homework before the shoot and find out what sort of personality they have. This will help you to capture a pose and mood that suits their persona.

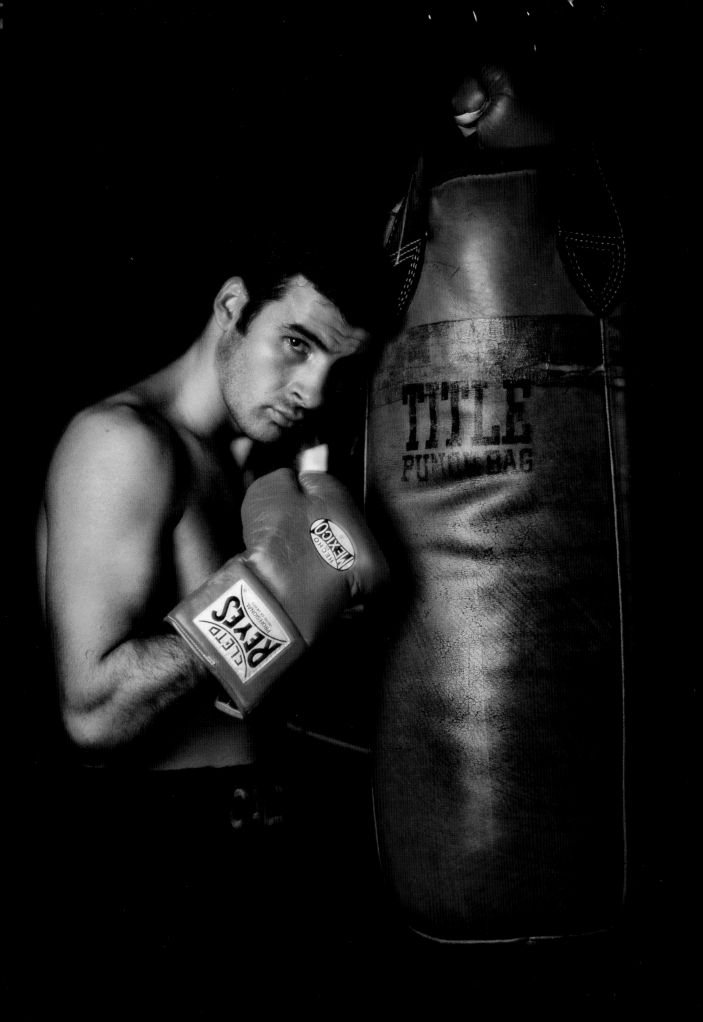

Low Saturation

I took this portrait of actor Dougray Scott on a very cold December morning for *The Sunday Times*. The location was an uninspiring hotel, so I took Dougray outside to make the most of the striking early-morning sun bursting through the cloudy sky.

To balance my exposure I took a meter reading of the sun and set the power on the Hensel Porty head to illuminate the left side of Dougray's head. Because the bright sunshine was overpowering the portrait I decided to desaturate the shot to balance the tones and retain all of the focus on my subject.

Setting the mood

When you're struggling to find an interesting location to take portraits, it can be a good idea to create some captivating lighting effects that will add interest to a potentially flat shot. To really bring this portrait of Dougray to life I decided to contrast the moody sky with some strong side lighting and leave the right side of his face in shadow. This also allowed me to lose some of the unwanted detail in the trees behind him and make them appear black in the final image. If the shadows in this portrait weren't so dark, the shot would have lost all of its power.

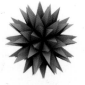

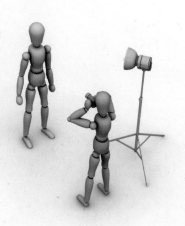

Camera	Canon EOS-1Ds Mk II
Lens	Sigma 105mm f/2.8 EX
Aperture	f/25
Shutter Speed	1/250 sec
ISO	100
Lighting	Hensel Porty

Side lighting

To shoot effective side-lit portraits, aim to set up and position your lights so one side of your subject's face is lit and the other half is totally in shadow. This way the line between light and dark will fall down the center of their face.

James Cheadle

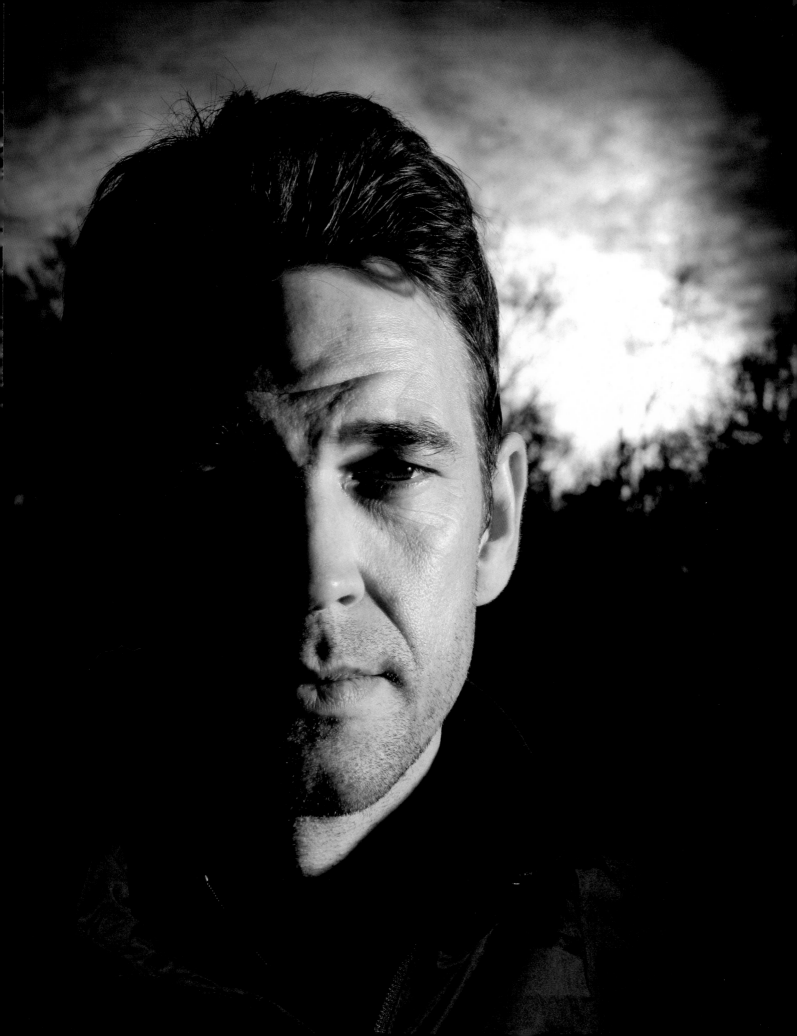

Street

I was in Istanbul shooting for *Performance Bikes* magazine when I took this portrait of a kebab seller next to the Ortaköy Mosque on the banks of the Bosphorus Strait. He only agreed to let me take his portrait if I bought my dinner from him, so after a large fish kebab, we had a quick 30-second photo shoot.

The kebab seller said he wanted to look cool for the photo, and I loved the way he suddenly switched from being a bubbly, smiley joker to the most serious-looking man on the street as soon as I started taking pictures. Because there was relatively low light, I set my DSLR to Shutter Priority mode, upped the ISO to 500, preset the shutter speed to 1/80 sec, and switched on the Image Stabilization on my 70–200mm f/2.8 lens in order to ensure sharp results.

Shooting from the hip

When photographing strangers on the street it's crucial that you're quick—in fact, the quicker the better. When I'm in cities looking for ideal subjects I try and predict the kind of lighting conditions I'm going to encounter and have my camera set so I can get the shot and move on quickly.

As a professional photographer it's important to know your camera inside and out so you can adjust the settings without pausing and looking at the buttons and dials. For anyone getting to grips with new equipment, it's good practice to alter the shutter speed, aperture, ISO, and focus modes over and over so that it becomes second nature when you're shooting under pressure.

Camera	Canon EOS-1D Mk II
Lens	Canon EF 70–200mm f/2.8L IS @ 70mm
Aperture	f/2.8
Shutter Speed	1/80 sec
ISO	500
Lighting	Available light

Life on the street

Think carefully but quickly about your compositions when shooting street portraits. Try and capture your subjects with a suggestion of their environment in the background. As this example shows, getting the Turkish flag and kebab menu in shot instantly adds context.

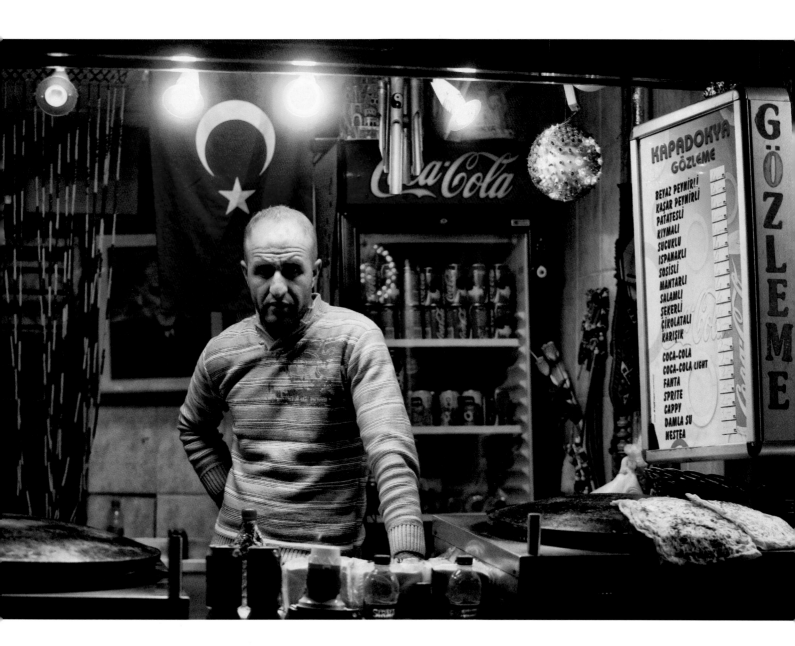

Black & White

This portrait of ex-Jam front man and solo artist Paul Weller was taken just before he was due to go on stage. I was commissioned by *Q* magazine to take a set of straight portraits against a white background, but this black-and-white image was one of those bonus shots you sometimes get at the end of a photo shoot.

Just as I was thinking about packing up, Paul sat on a flight case backstage and started tuning his old, beaten-up Gibson acoustic guitar. I managed to shoot off two frames before Paul remembered I was there and started posing again. I fortunately had an assistant on the shoot, so while Paul was sat down strumming his guitar, my assistant quickly pointed a Bowens head his way to capture him in better light.

Don't look into my eyes

Maintaining eye contact with your subjects isn't always necessary, as you can still capture stunning images without any eye contact. This black-and-white portrait of Paul works well because he isn't looking into the camera. The fact that his attention is on the guitar and not the camera also gives the shot a very natural, honest feel. Asking your subject to focus on something away from the camera can be a great way to introduce intimacy to your images.

Camera	Mamiya RZ67
Lens	Mamiya 110mm f/2.8
Aperture	f/4
Shutter Speed	1/60 sec
ISO	400
Lighting	Bowens Esprit

Maintaining focus on subjects

Without any distracting colorful objects in the background or foreground leading the eye away, black-and-white images help to make sure your subjects remain the focal point in the frame.

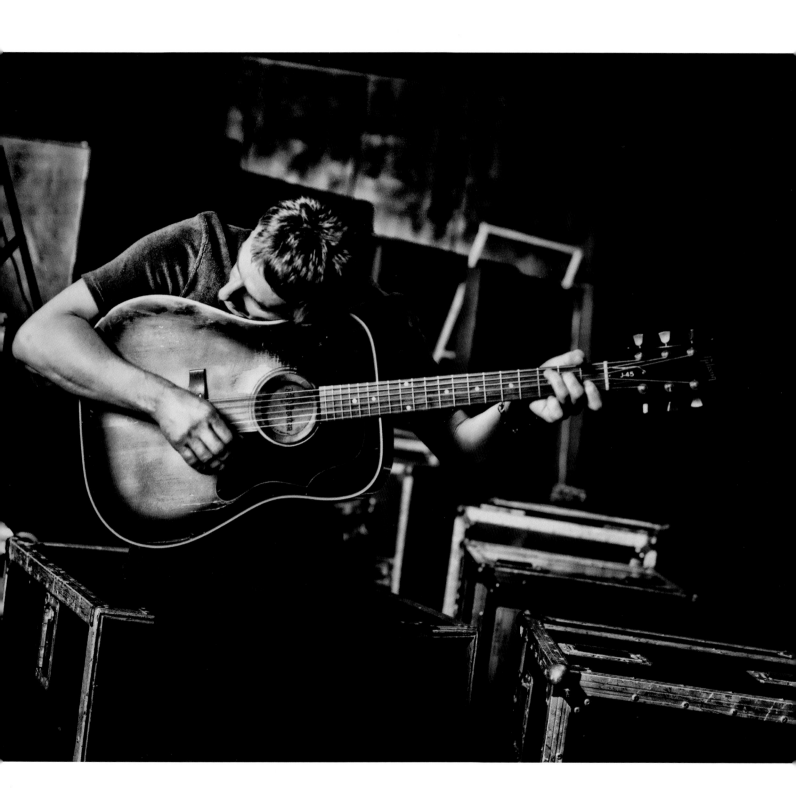

Black & White

This photograph of World Superbike Champion Carl Fogarty was taken in a studio for the cover of *Total Sport* magazine. Carl has one of those faces that looks great in black and white due to his incredibly intense stare and gaunt features.

To set up this shot I lit Carl with one Elinchrom head positioned high above him and two blackboards placed either side of him to prevent any unwanted light bouncing back onto the sides of his face.

Reading faces

Some people suit black-and-white portraits more than others. The more interesting the facial features, the better people look with the color stripped out because you'll really be able to reveal the person's true character.

This portrait of Carl looked strong in color, but all the different skin tones it captured distracted from presenting his personality, so converting to black and white was the better option in this instance. To learn how to make effective black-and-white conversions in Photoshop turn to pages 166–167.

Camera	Mamiya RZ67
Lens	Mamiya 110mm f/2.8
Aperture	f/5.6
Shutter Speed	1/250 sec
ISO	400
Film	Ilford HP5
Lighting	Elinchrom

Back in black

To ensure lighting doesn't bounce off reflective surfaces and affect your portraits from the rear and sides, use black backdrops to absorb the light. Carry a collapsible black velvet background with you. If you're hiring a studio they should have backdrops on hand.

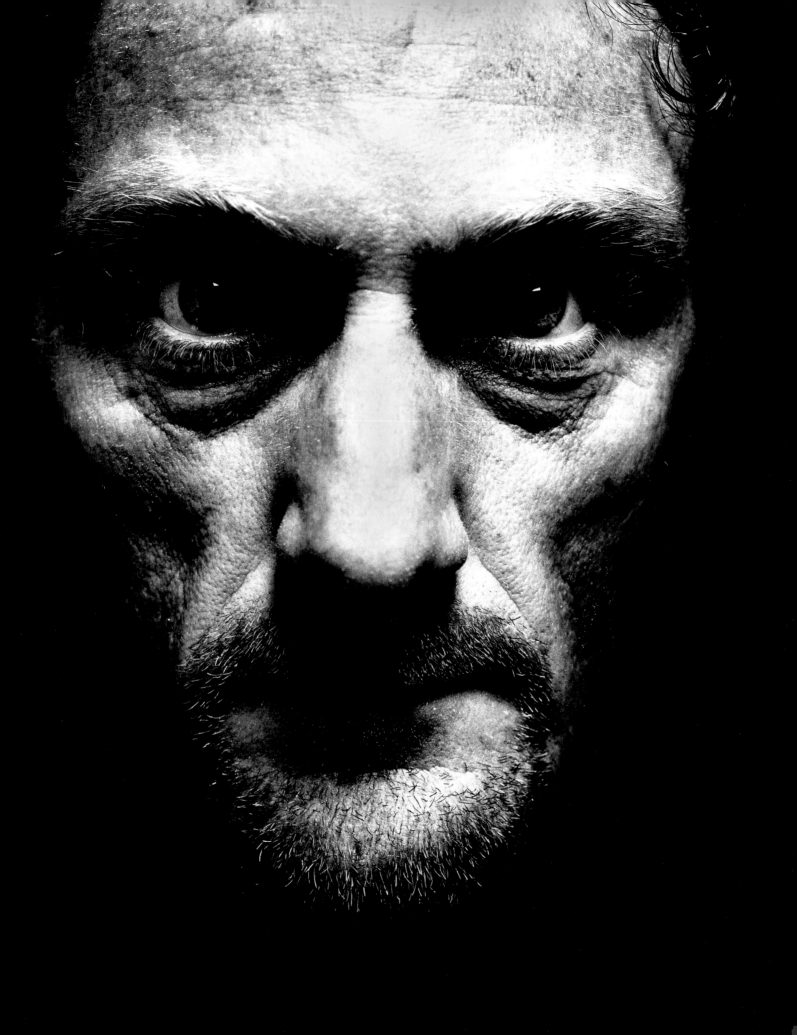

HDR

This portrait of European and PGA Tour golfer Ian Poulter was shot for *Golf World* magazine. To give the shot some extra punch I decided to use the high dynamic range (HDR) technique. There are two ways of shooting in HDR, also known as tone mapping or exposure fusion. Ideally, you need to take three or more shots of the same subject on a tripod using bracketed exposures, which capture the varying tonal disparities of the subject. These images are then blended together to create one frame that has detail in the darkest shadows, midtones, and brightest highlights.

The problem when you're shooting portraits, however, is that even the tiniest movement in composition or facial expression means that the images won't match when they are blended together. So for portraits it's best to use the single-exposure HDR technique, where you process the same image three times to reveal a high range of tones.

Single exposure HDRs

The single-frame method is a great way of producing a HDR portrait. The trick is to shoot one perfectly exposed RAW file and then use Adobe Camera Raw (part of Photoshop) to create three different TIFFs—one exposed for highlights, one for midtones, and one for shadows. You can then use Photoshop or a dedicated HDR program such as Photomatix Pro to merge your three TIFFs into one HDR image. Both of these programs offer you complete control over the strength of the effect, so a bit of experimentation is often necessary before you get the HDR look you're after. For more details on HDR image-editing techniques, see pages 168–169.

Camera	Canon EOS-1Ds Mk II
Lens	Sigma 105mm f/2.8 EX
Aperture	f/14
Shutter Speed	1/200 sec
ISO	125
Lighting	Bowens Esprit

Dynamic lighting
When taking HDR portraits remember to light your subjects fairly evenly but from one side so you can capture some detail in the highlights, midtones, and shadow areas. Don't use so much side lighting that you're unable to capture any detail in the darker tones, but don't use too little either—if you create a flatly lit original portrait the final HDR image will also look flat.

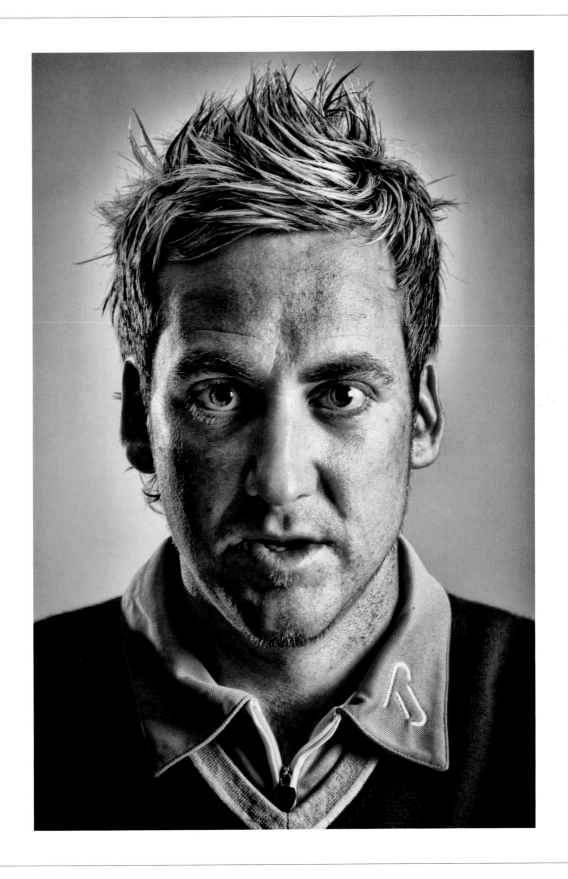

Full Face

I was at the world-famous Wentworth Golf Club in the UK shooting various portraits when Spanish golfer Miguel Ángel Jiménez—also known as The Mechanic due to his love of fixing old cars—agreed to be photographed warming up on the driving range. Miguel is also well-known for his love of cigars, so I encouraged him to light one up in order to create a unique and smoky atmosphere for this full-face portrait. I photographed Miguel with and without flash, but this shot taken in available light is my favorite.

Focus on the eyes

When shooting full-face portraits it's vital to focus on the eyes. Whether you get this right can make or break the shot. You can also add extra impact to the final result by using a fairly long focal length and a wide aperture to capture a shallow depth of field. I used an aperture of f/3.5 for this full-face shot at a focal length of 68mm. This really draws attention to Miguel's facial features and away from any distractions that there may be in the background, as well as knocking the cigar in the foreground out of focus.

Camera	Canon EOS-1Ds Mk II
Lens	Canon EF 28–70mm f/2.8L @ 68mm
Aperture	f/3.5
Shutter Speed	1/60 sec
ISO	200
Lighting	Available light

Overcast weather
It's easy to think that dull weather equals dull outdoor portraits, however overcast weather can enable you to capture a portrait without any harsh shadows falling over your subject's face. Overcast conditions can also produce better facial expressions, as your subjects won't need to squint.

James Cheadle

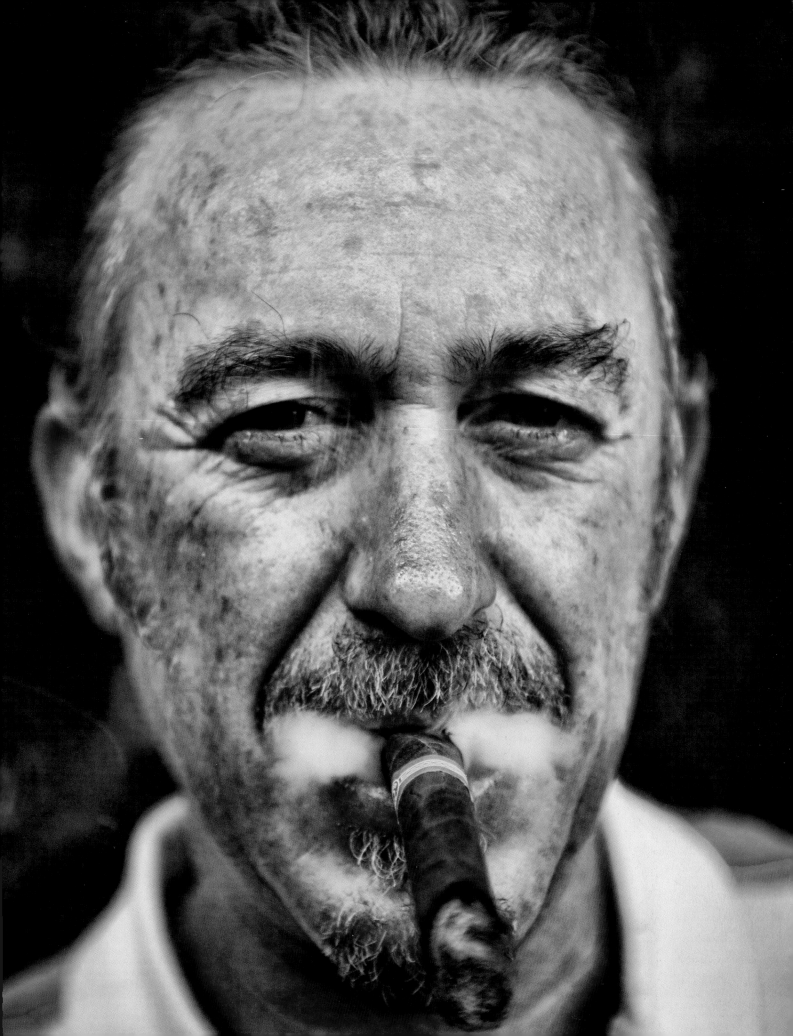

Full Face

I shot this full-face portrait of high-profile BBC Radio presenter Chris Evans at a hotel for *The Sunday Times*. Time is usually limited on celebrity shoots, but this shoot with Chris proved to be the exception and he went out of his way to make sure I got the shots with minimal fuss. He was a real pleasure to photograph.

I set up a full-length white paper backdrop for Chris to stand in front of. I deliberately didn't light the background so that it remained dark and I could instead light the area just behind Chris's head to create a spot effect. I placed a large softbox to the left of Chris in order to light his face, with the right side of his face dropped into shadow in order to introduce some contrast into the portrait.

Adding extra interest

Accessories, such as the eye-catching glasses that Chris wears in this picture, are a great way to add interest to a full-face portrait. The original idea for this shot was to recreate legendary photographer David Bailey's iconic 1960s photo of actor Michael Caine, who also wore similar thick-rimmed glasses. But, as is often the case, the portrait of Chris took on a life of its own and I ended up with an arguably equally striking image.

Other great ways of bringing something extra to a full-face shot are to ask the subject to rest their head on their hands or incorporate items of clothing, such as a hat or scarf.

Camera	Mamiya RZ67
Lens	Mamiya 110mm f/2.8
Aperture	f/4
Shutter Speed	1/250 sec
ISO	100
Film	Fuji Provia
Lighting	Bowens Esprit

Scanning film

If you're shooting on film you'll still need to scan your portraits to integrate them into a modern digital workflow. Your local imaging bureau can scan them for you, or you could consider buying your own scanner. At the top end of the scale is Nikon's brilliant Super Coolscan film scanner, or more affordable options are flatbed scanners from Epson and Canon.

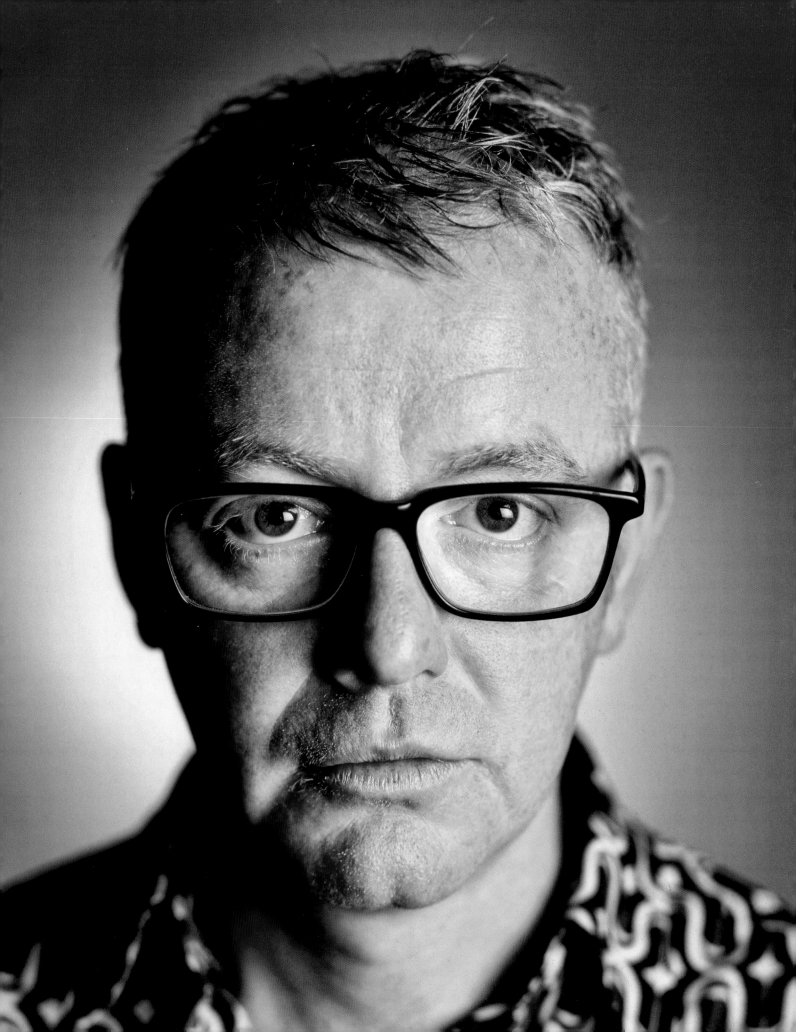

Performance

This performance portrait of highly distinguished opera singer Susan Graham was commissioned by the BBC and shot at The Berliner Philharmonie in Berlin, Germany. The shoot was due to take place in the main auditorium, but unluckily for us the roof of the building had caught fire the day before so the entire building was shut. Apart from a lone security guard on one of the exits we were the only people there. This shot of Susan involved her spinning in circles whilst I fired away on my Canon. Susan was lit with a large softbox to the right of the frame and a gold umbrella was placed to the left behind her. A grid was also angled to the back of Susan to highlight her hair.

Interacting with your subjects

To be a successful professional photographer you have to learn to be a bit of a social chameleon. When shooting world-class performers like Susan it's important to approach the shoot with a certain attitude in order to really make your subject feel comfortable and at ease in front of the camera.

In order to create the energy required for a vibrant performance portrait you will need to inject some well-timed encouragement into the shoot. I find it very beneficial to let the artist know how the shoot is going by letting them see the portrait shots on your camera's rear LCD. This helps them feel more involved in the direction of the photo shoot, and working together is absolutely essential in order to get a successful result.

Camera	Canon EOS-1Ds Mk II
Lens	Canon EF 70–200mm f/2.8L IS @ 150mm
Aperture	f/3.5
Shutter Speed	1/125 sec
ISO	100
Lighting	Bowens Esprit

Building rapport

Being friendly with your subjects is essential to help them relax before and during the shoot. A little bit of charm and a few compliments can go a long way in helping to get the best out of people.

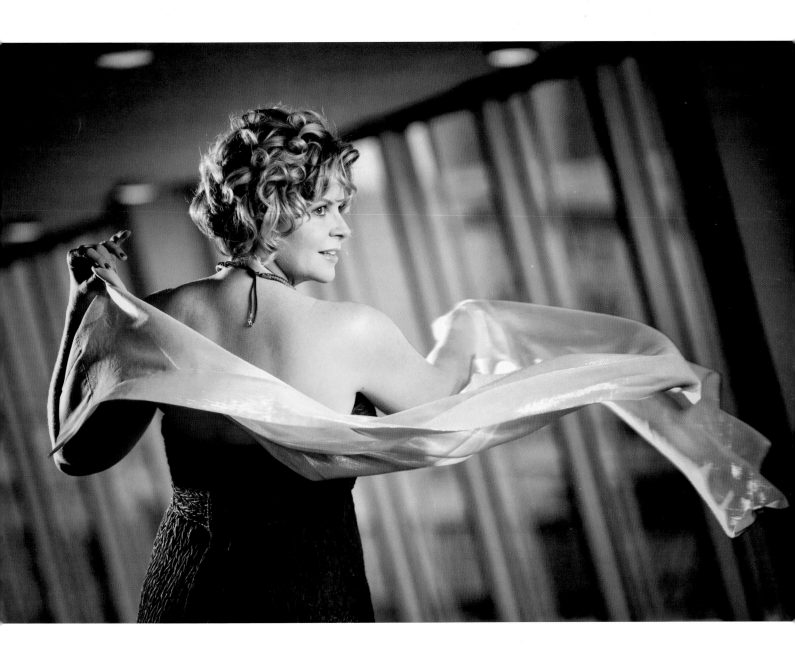

Performance

I encountered all sorts of challenges shooting this performance portrait of pop sensation Mika. I'd been following Mika on his Far East tour for *Q* magazine, and due to Mika's hectic travel schedule, we were struggling to find the time to shoot a portrait for the opening double-page spread of the feature.

We were in Tokyo, Japan, when we eventually managed to organize the shoot on the morning of the last show of the tour. My idea was to incorporate the spaceman section of Mika's live show and place him in a Japanese city setting. Due to time constraints we set up the shoot just two minutes walk from the Ritz-Carlton hotel where we were all staying.

Bending the rules

In an ideal world I would have applied for a permit to set up lights for a photo shoot in downtown Tokyo, but this wasn't possible due to the shoot being arranged at the eleventh hour. Fortunately, our interpreter said that if we could work without stands or tripods then we could, in theory, shoot on the streets in the Roppongi district near the hotel. Thankfully, I had help at hand. Mika's PR rep held one light in front and to Mika's left, and my assistant held one behind and to Mika's right. We chose to shoot down a side street to avoid unwanted attention, but still had the continuous problem of persistent traffic, pedestrians, and fans asking for autographs. However, after 15 minutes we had the shots we needed.

Camera	Canon EOS-1Ds Mk III
Lens	Canon EF 24–105mm f/4L IS @ 35mm
Aperture	f/5.6
Shutter Speed	1/125 sec
ISO	160
Lighting	Elinchrom Ranger Quadra

Permission for performance shoots

To get permission and permits for live performance shoots you'll need to work directly for the label/artist or for a respected publication that can apply to a venue or performer's record label beforehand. The usual protocol when shooting at a live performance is that you are allowed to shoot during the first three songs only, without using flash.

James Cheadle

Rock Star

I was commissioned by *Guitarist* magazine to photograph System Of A Down lead guitarist and singer Daron Malakian at The Brixton Academy venue.

As is typical with these kinds of rock band shoots, I had a very limited choice of locations because the shoot was scheduled just 45 minutes before the band were due on stage. This meant I needed to shoot in the area just to the back of the stage in the 15-minute window I'd been allocated.

Adding color

Using colored gels on your lights can be a quick and easy way to save an otherwise bland and dull portrait. For this shot, I fitted a green gel on a Bowens head and directed the light toward the boring black-and-white wall behind Daron. I used a yellow gel on another head to add warmth and aimed this at him from behind to act as a backlight, which also created a nice yellow highlight on his guitar. Without this added color the shot would have been lifeless, with just a large block of dirty white behind Daron's head.

The left side of Daron was lit with a medium-sized softbox on a Bowens Esprit head, which also provided some neutral light and balance to the portrait.

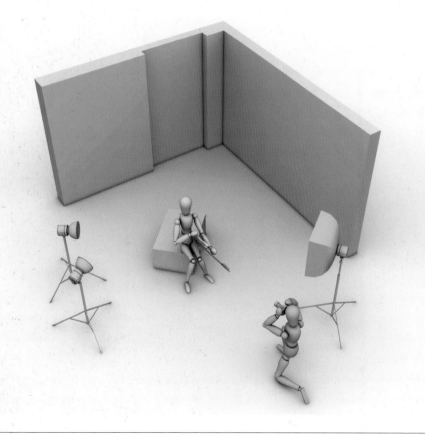

Camera	Mamiya RZ67
Lens	Mamiya 110mm f/2.8
Aperture	f/5.6
Shutter Speed	1/125 sec
ISO	100
Film	Fuji Provia
Lighting	Bowens Esprit

Bad boys

Getting male rock stars to wear sunglasses and to pose with their guitars as though they're weapons can help to enhance their "bad boy" image, and also create a fitting rock 'n' roll feel for your portraits.

James Cheadle

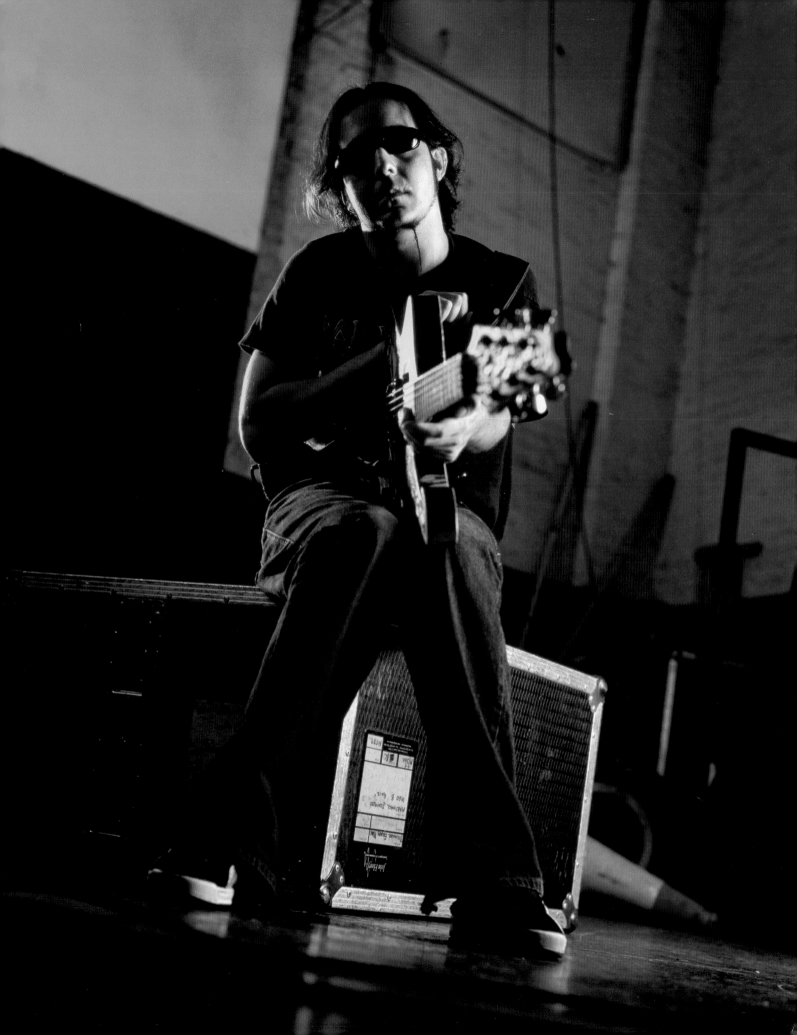

Rock Star

Joe Giron was commissioned by music magazine *Metal Hammer* to photograph the American heavy metal band Metallica for a cover and feature article that coincided with the release of their *St. Anger* album.

Giron flew from LA to San Francisco and met the band at their rehearsal space. There wasn't much room there to shoot, but they did have a black backdrop set up to one side that he decided would make a perfect, clean backdrop for the shots.

The magazine wanted a cover shot of lead singer/guitarist James Hetfield looking suitably angry, so Giron lit the portrait from below to accentuate James's facial features. He had worked with the band a few times previously so he knew James was an agreeable gent who wouldn't mind taking some direction to get the angry pose that was needed. He set his lens at James's eye-level in order to help exaggerate this great facial expression.

Lights, camera, action

To set up this shot Giron placed a Dynalite head with a small softbox on a stand below James and aimed it upward. A warming gel was used on the flash head attached to a Dynalite M1000 pack set to half power, and Giron used a second light placed from high up to James's left to provide a key light source, which helps to separate his head, hands, and T-shirt from the backdrop. Another Dynalite M1000 pack was set to full power, and over the flash head he added a diffusing gel to soften the light a little. He also "flagged" the key light using a 24 × 36in/61 × 91.5cm black square that blocks light so that there wouldn't be any spill on the black background, and to ensure flare wouldn't reach his camera lens.

Camera	Mamiya RZ67
Lens	Mamiya RZ 110mm f/2.8
Aperture	f/11
Shutter Speed	1/60 sec
ISO	100
Film	Kodak Ektachrome VS100
Lighting	Dynalite M1000

Your online portfolio

A decent website is essential in order to enable potential clients to quickly view your portfolio. Ensure your site is easy to navigate and displays a good range of your best portraits in clearly headed categories, and make sure you keep it up-to-date.

Reportage

Reportage portrait photography is all about reacting quickly so that you can capture your subjects looking natural. I took this shot at a lawnmower race meeting one hot summer evening in Arizona, minutes before the competitor was due to don his crash helmet and start racing.

I lit the subject using a handheld Canon Speedlite flash linked to my DSLR with Canon's ST-E4 infrared ETTL system, which works beautifully in these kinds of situations. Being able to get the flash as far away as possible from the camera produces the best results in the lighting conditions.

All set and ready to go

When I started out in news photography one of the first things I was taught was to always have my camera set up and ready to shoot. When it comes to reportage portraiture, I cannot stress how important this is. When an event occurs, you need to be able to pick up your camera, shoot without thinking, and get a result.

My chosen technique is to keep my pro Canon DSLR set on Shutter Priority (Tv) mode, with the shutter speed set to 1/250 sec. This means that if I need to grab a shot quickly, the shutter speed ensures the subject is frozen and the camera will automatically set the aperture for the correct exposure. It's also a good idea to leave the focus at around 6½ft/2m so that if you haven't got time to look through the viewfinder you'll have a greater chance of capturing your subjects in focus.

Camera	Canon EOS-1Ds Mk II
Lens	Canon EF 16–35mm f/2.8L @ 35mm
Aperture	f/3.5
Shutter Speed	1/80 sec
ISO	320
Lighting	Canon Speedlite 580 EX Speedlite flash unit

Stealth shooting

A good reportage photographer will have good stealth skills. It takes practice, but learning to be "invisible" and going unnoticed, and not interfering with your subjects, will help you to capture real-looking reportage shots.

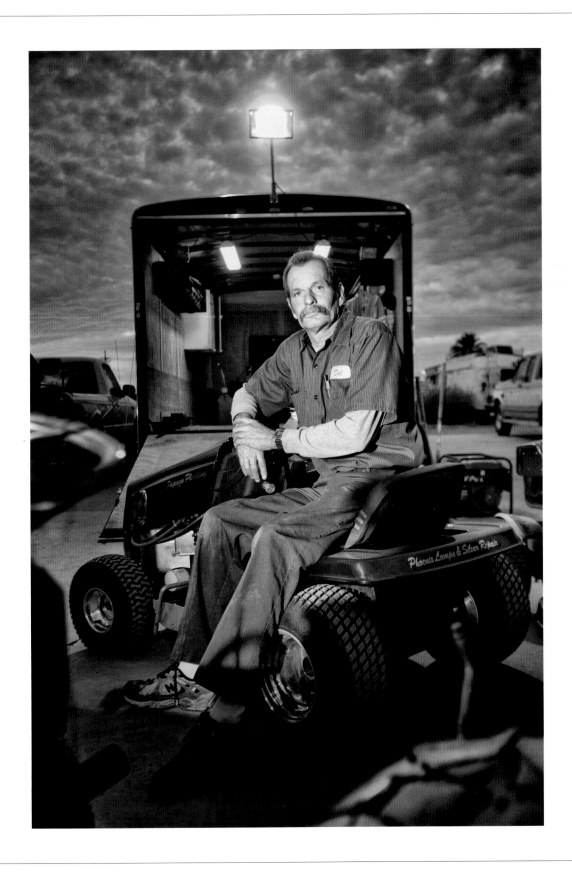

Reportage

This reportage portrait of an amateur classic bike racer was taken at Brands Hatch circuit just before the last race of the day. The clouds were gathering and it was about to start raining heavily, however I still needed a strong image that would sum up the day for my client, *Bike* magazine. I grabbed this shot in a matter of seconds while the motorbikers were gathering in the holding area. I used one handheld Canon Speedlite flash off-camera and to the subject's right in order to light his face.

Telling tales

When shooting in the reportage style it's important to get the story across in your images. Essentially, you need to be a fly on the wall to truly convey the feeling of the event you're covering. Knowledge of your subject matter can be a massive bonus, as this will help you to be in the right place at the right time. When composing these kinds of portraits it can help if you use a wide-angle lens, and allow for plenty of room around your main focus, so that you can incorporate the surroundings that are relevant to the story.

Unlike most portraits, you'll find that you will have little control over what's happening around you when shooting in this style, so you'll need to be patient. Very often, portrait sessions can be quick, but with reportage photography it can take hours or even days to get "the" shot.

Camera	Canon EOS-1Ds Mk II
Lens	Canon EF 16–35mm f/2.8L @ 19mm
Aperture	f/7.1
Shutter Speed	1/160 sec
ISO	160
Lighting	Canon Speedlite 580 EX flash unit

Trust me

Once you've gained people's trust it will help them to relax and forget you're there taking photos. This will allow you to capture true, natural, and nonposed reportage portraits.

James Cheadle

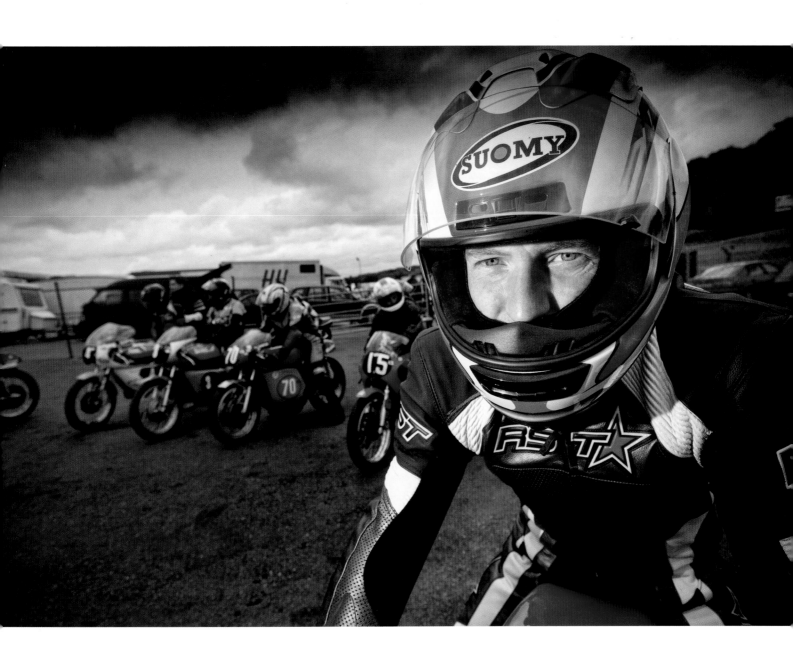

Image Manipulation

This shot of Michael Palin, a comedian and actor who is also known for his TV travel documentaries, was taken for the launch of his book, *Sahara*, a publication tied to his BBC series. I had to photograph Michael at his agent's office, which turned out to be tiny! Thankfully Michael was a joy to work with and didn't think twice about whipping off his shirt and shoving his head through the hole in a wooden board covered with sand, to make it look like he was buried up to his neck in the desert.

To complete this portrait I combined it with a classic desert backdrop in Photoshop, manipulating the colors and tones until they matched. See pages 170–171 for a Photoshop tutorial on merging a portrait with a new background.

Creating the right light

Shooting in small spaces presents many challenges. There is a lack of room to set up lights and softboxes, and low ceilings and white walls bounce light around, leaving you with little control when attempting to light your subjects. Walls and ceilings that are too close to your subjects will also act as reflectors, resulting in flat light and boring portraits. To get around these problems I stuck a big black sheet of fabric on one wall and then set up a small softbox to the left side of Michael's face. Another light with a gold umbrella lightened and warmed up the shadows on the right side of his face, and a light with a honeycomb attachment highlighted the back of his head.

I used a Mamiya 55mm f/4 lens for this composition, and positioned myself close to Michael and at his eye level. Because Michael is a natural comedian, he was brilliant at producing a range of wonderful facial expressions.

Camera	Mamiya RZ67
Lens	Mamiya 55mm f/4
Aperture	f/5.6
Shutter Speed	1/60 sec
ISO	100
Film	Fuji Provia
Lighting	Bowens Esprit

Combining images

When shooting portraits that are going to be combined with a different (or fake) background, shoot your subject against a plain backdrop. This will make it easier to select and merge your two images together.

James Cheadle

Romance

I flew to Italy to photograph French pianist Jean-Yves Thibaudet while he was performing at the annual Tuscan Sun Festival in the hilltop town of Cortona. I started off shooting Jean-Yves in the beautiful Teatro Signorelli theater for my client, the BBC, but felt I needed to add some romance to the portrait, so we headed out into the streets. I wanted to keep the lighting as natural as possible for this portrait, so to highlight Jean-Yves I only used one battery-powered Elinchrom Ranger Quadra head set as low as possible off to his right.

Creating the mood

All subjects need to be treated differently, and I always assess each person on a case-by-case basis. Jean-Yves is a sophisticated and passionate man, so I decided he would be perfect to photograph in a tasteful, romantic pose. To capture the desired style I organized a selection of Vivienne Westwood clothing be flown in from London, and for the all-important prop I sent my assistant out to purchase a bunch of roses, which added some color and romance to the shot. Jean-Yves provided the charisma, which really contributed to the end result.

Camera	Canon EOS-1Ds Mk III
Lens	Canon EF 70–200mm f/2.8L IS @ 70mm
Aperture	f/4
Shutter Speed	1/250 sec
ISO	100
Lighting	Elinchrom Ranger Quadra

Love is...
There are many ways to shoot romantic portraits, but to maintain a classy feel, try to avoid clichés such as inappropriate nudity or subjects wearing bright red lipstick.

James Cheadle

Comedy

I was commissioned to photograph comedian Harry Hill for men's magazine *Loaded*. Not many people know that Harry is also a keen artist who loves painting ironic portraits of famous celebrities, so I decided to meet him in a gallery and use his artwork as props to give the portrait some more interest.

Just seconds into the shoot Harry treated me to his full-range of amusing and bizarre facial expressions. Rather than directing or offering feedback, I was able to sit back and photograph Harry at leisure. I used three Bowens Esprit heads to light Harry, with two facing toward him and one lighting the back of the room.

King of comedy

When shooting portraits you should always aim to capture your subject's personalities. When confronted with a famous comedian it's perhaps even more important to catch their extroverted nature on camera. To help you achieve this, and to create a comedic feel with your portraits, you'll need to quickly develop a connection with your subject so that they're comfortable and confident enough to pose for you.

A tried and tested technique I use is to continuously offer compliments and encouragement, which helps to maintain the right kind of energy in the room.

Camera	Canon EOS-1Ds Mk III
Lens	Canon EF 24–105mm f/4L IS @ 35mm
Aperture	f/5.6
Shutter Speed	1/125 sec
ISO	160
Lighting	Bowens Esprit

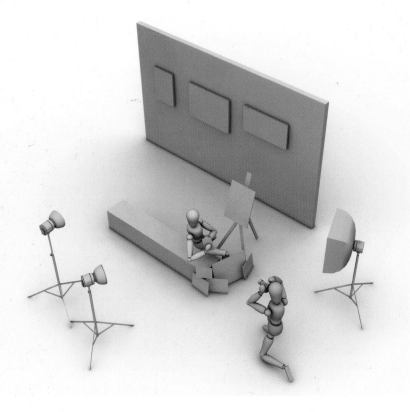

Good atmosphere
Creating a relaxed, fun atmosphere on shoots is essential for capturing good portraits. A simple trick is to play music in the background—this ensures there are no long silences between you and your subject that will affect the mood in the room.

Comedy

Golf World magazine asked me to photograph comedian Dom Joly at a golf course near his home in Gloucestershire, England. I can remember arriving at the location early and feeling my heart sink as I discovered the clubhouse was modern, charmless, and not very photogenic. After a 20-minute scout of the grounds I came across a gardener's hut, which was perfect for funnyman Dom. I'd brought a set of golf clubs and a cheap plastic monocle with me to use as props, and lit Dom with a single battery-powered Hensel Porty head.

Small things

Sometimes it's the little things that can make a comedy portrait work. For example, in this shot it's the monocle and golf club that really bring Dom to life—they give him the little encouragement needed to really get into character. The great thing about monocles is that they automatically make your subjects pull a funny face. Coupled with the shabby old hut and the golf club, I already had the makings of a top comedy shot—all Dom had to do was strike a pose.

Camera	Canon EOS-1Ds Mk II
Lens	Canon EF 50mm f/2.5
Aperture	f/8
Shutter Speed	1/125 sec
ISO	100
Lighting	Hensel Porty

Are you trying to be funny?
It's often said that some comedians can be downbeat and miserable when you meet them in person. If this is the case, use this to your advantage and capture a "tears of a clown" sad portrait instead!

Shooting Tips

To be a successful portrait photographer you need to be confident in your photographic skills, from getting perfect exposures and sharp shots every time, to being able to connect quickly with your subjects and capture great results under pressure. You also need to be self-assured when using all of your equipment, from your camera to your lens choice and lighting setups. In this section we offer advice on all of these crucial elements to help you become more professional and efficient in your approach to portrait photography.

We begin with the best way to handle projects and commissions, fees and copyright, and how to prepare and plan ahead for shoots, how to deal with pressure and tight schedules, and how to choose the best studio and outdoor locations. We then reinforce all you need to know about getting the best exposure settings every time, and we highlight the importance of good metering and focusing.

We also reveal professional secrets for successful studio lighting setups and how to tackle lighting outdoors, plus the best ways to capture natural-looking portraits without lights. We round things off with techniques on creative compositions and the importance of using histograms on your DSLR when reviewing shots on high-pressure shoots.

If you follow our suggestions, all of these photography skills will become second nature and your confidence will grow, leaving you to enjoy taking first-class portraits.

Projects & Commissions

Professional portrait shoots usually begin with a commission or booking from a client. The client has come to you, perhaps after a recommendation or after seeing your work in a publication or on your website, so will likely already be confident you'll do a good job. But to make sure you deliver—especially if it's the first time you've worked with this client, and to secure any potential future business—there are some key factors to consider.

Understanding the assignment

If you're working for a publication or a big brand you should get a brief from the client with clear instructions explaining what they want to achieve, who you'll be photographing (including details of the portrait style they'll expect), plus a full shot list, usually against a schedule. Bear in mind that your client may not be so decisive or used to dealing with photographers. If you're shooting a corporate group, they may want to project their new image or might only have a vague description of the style they want. If you're photographing families, their requests could be equally ambiguous.

Never second-guess and go into a shoot with a rough idea of what you think the client wants; they're likely to be picturing something different than whatever you produce on the day, which can create a pressurized situation that you'll have to rectify—all against the clock.

Portrait styles

It's a good idea to do some research on the publication or company before the shoot to find the photographic style that will best suit them. Meet with or email the client beforehand and show them portraits from your portfolio or scrapbook that fit their concept or that you think they will like. You could also get them to show you examples of portraits they like that fit with their ideas, or ask them to send you a moodboard with photos in a similar style or with the same feel they're after. Either way, make sure you both agree on a clear portrait style before the shoot.

1 To help your clients pin down a photographic style, ask them to send you a mood board with a selection of different images and influences they like to help set the right tone.
2 When working to a client's call sheet or shot list, prioritize the order of the shots, starting with the most important shots first.

Shot lists

If your client has emailed you a shot list (aka a call sheet), go through it thoroughly before the shoot to make sure you'll be able to capture all of the portraits they've requested within the timescale, or within your allotted time if you're photographing celebrities or personalities. Factor in any changes in lighting and location, and flag any potential problems with your client so that they're not disappointed. Politely offer a solution or alternative, such as sticking to one or two locations or reducing the amount of lighting setup changes needed, so they realize that you're not being difficult but that their expectations may be unrealistic.

It is seldom possible to get every shot on the list, as photo shoots invariably take longer than expected. Make sure your shots are in order of priority so that you'll get the most important photos completed first.

Copyright and licenses

Two of the most important points to discuss when accepting commissions are image copyright and license. In the modern world of professional photography, copyright is becoming more and more of a factor when negotiating a shoot with a client. It's important to understand the value of retaining copyright in everything that you shoot, and to understand the difference between "copyright" and "license." Copyright is the legal right of the photographer/client to control the use and reproduction of the original creative work, whereas a license is an official document that gives permission as to how, where, and when you/your client uses the images by the owner of the copyright.

When shooting new material, the copyright automatically defaults to the photographer, who is the originator of the work. However, in an increasingly competitive field, less experienced photographers are willing to sign away their copyright in a desperate bid to land the job.

It's advisable to also be specific with your clients as to how the images will be licensed. The three main factors to consider with licenses are usage (PR/editorial/advertising, etc.), how long the license will run for, and where the license will run (UK/Europe/USA/global, etc.).

In reality, it's usually possible to negotiate a deal with the client that grants them a license to use the images in the way they wish, and for a period of time that suits you both, leaving you the option to then resell or reuse your images elsewhere after the agreed timeframe.

3 An up-to-date and diverse portfolio is an essential tool for any portrait photographer; take it with you when meeting new clients to help prove your professional credentials.

Preparation, Location & Directing

If you go into a photo shoot unprepared you are putting considerable pressure on yourself to perform, which could end up with you failing to deliver on the day. This not only means an unhappy client, but could also damage your reputation. Remember that photographers trade on their name, so if word spreads that you're unprofessional work could soon dry up, leaving you with a big problem that could have been avoided with some simple planning.

Location shoots

If you're asked to pick a location, make sure to do your homework. Scout out places that are accessible for your clients and tick all the boxes. Work out where the sun will be when you're shooting, have a contingency plan if the weather turns bad, and find out if there are any indoor locations nearby. Having backup plans and being able to adapt is all part and parcel of being a professional photographer.

If you're meeting on location, make sure you know how to get there and work out your journey time, making sure to have your client's contact details with you in case you need to call them. Always aim to arrive at least an hour early—this will allow for any travel delays, and once you've arrived it will give you time to relax and checkout the location before you start setting up.

Building good rapport

Without good rapport your subjects won't engage with you and your camera, and that will mean lifeless portraits. Pro portrait photographers generally have good social skills, which enable them to connect with their subjects. You don't need to be as charming as George Clooney; you just need to be warm and sociable.

A top tip is to meet with your client beforehand and have an informal chat. Start off by getting to know them, and once they're warmed up you can start talking portraits. Do this in a professional but friendly way. If you haven't already discussed styles, ask what sort of portraits

1 Arrive on location early so you can scout out the best spots for the best shots.
2 Being able to connect with your subjects can really help to bring life and energy to your portraits.

they're after and bring out your portfolio to show them examples that you think would suit them.

Before you start the shoot it's a good idea to play some music to put your subject at ease. Unless they're models or celebrities used to having their photo taken they'll probably say they always look terrible in photos. Be complimentary, or make a joke and tell them you can do wonders with Photoshop!

Directing shoots

Be confident and move around to capture different angles and compositions, giving your subjects encouragement and clear directions. Keep a sense of fun and regularly show your subjects the shots on the camera's LCD or a computer screen if you're shooting tethered. Showing people their portraits makes them realize that they do look OK on camera, and gives them the confidence for the next round of shots.

Keep chatting and communicating with your subject and don't be discouraged if the first 10–15 minutes of portraits aren't brilliant. Once people get used to you taking photos they'll soon relax, which will show in their eyes and facial expressions—all of which means better shots for you.

Your pay structure

Some people find it awkward to discuss photographic fees with clients, but you'll need to learn to communicate clearly to avoid any difficulties during the commissioning process or after a shoot. When setting your fees, don't just charge for your shooting time; it's also essential to consider the value of the images to the client.

The fee a professional photographer is able to charge is based upon their skills and experience, how and where your client plans to use the images, and the client themselves. It's a complicated business, as fees will vary

from country to country and market to market, so be prepared to negotiate a fee on a case-by-case basis. Be savvy and research the market you intend to operate in, and then price accordingly. Never be afraid to charge what you think you're worth.

Running a successful freelance photography business can be very expensive, and all of your photographic kit, computer equipment, operating costs, and postproduction time needs to be factored into your fees.

3 Be confident and communicative when directing your subjects on shoots. A good way to encourage people and give them feedback is to show them images on your camera's LCD.

Taking Control of Exposure

As a professional photographer you'll need to learn to take control of your exposures. Less experienced photographers often rely on semiauto modes and their DSLR to tell them if their portraits are correctly exposed, but this will only hold you back. To help you progress in the professional world of portraiture you'll need to become the boss of your exposures.

Manual control

Shoot in Manual mode in order to take full creative control of your portraits. This will allow you to set the aperture and shutter speed to suit the portrait style, including the ability to control depth of field and how bright or dark your subjects and their surroundings appear, and to also determine which areas of your images are exposed for shadow and highlight areas.

It's also essential to use Manual mode when shooting portraits with lights, as your DSLR has no idea how to meter and expose for artificial lighting, unlike when using semiauto shooting modes and dedicated Speedlite flashes. In manual mode you can also get creative with your exposures and set your aperture to retain background detail, while at the same time the power setting on your lights will expose for the subject.

1 To take control of your exposures it's best to shoot using your DSLR's Manual mode. This way you are in charge of both aperture and shutter speed.

Back to basics

Despite the obvious advantages of shooting in Manual mode, if you haven't yet built up your confidence there are some positives to shooting in semiauto mode.

Use Aperture Priority (Av or A on mode dials) to set aperture while your camera controls shutter speed for a standard exposure. To blur backgrounds behind your subjects, create a shallow depth of field using a wide aperture (e.g., f/2.8 or f/4), or to keep backgrounds in focus, create a greater DoF using a narrow aperture (e.g., f/16 or f/22).

Use Shutter Priority (Tv or S on mode dials) to control shutter speed while your camera sets an aperture for a standard exposure. Use fast shutter speeds (e.g., 1/250 or 1/500 sec) for pin-sharp shots, or slow it down (e.g., 1/20 or 1/50 sec) to capture movement and motion blur.

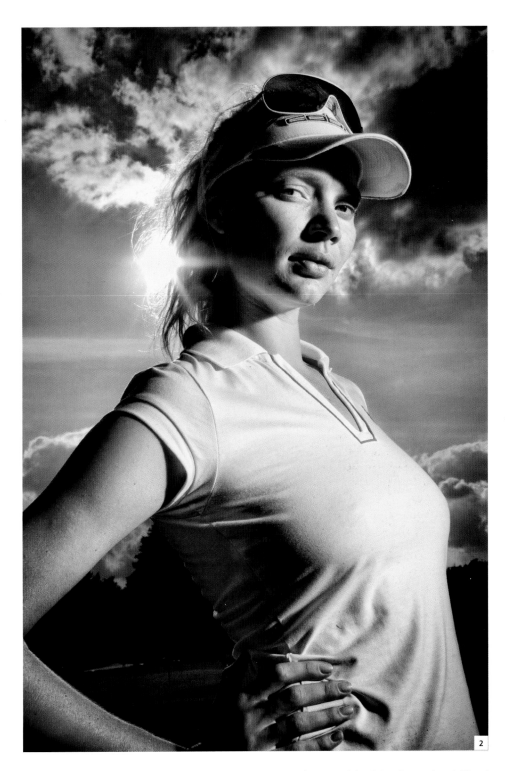

2 When shooting portraits on location and directly into the sun, shoot in Manual mode and set your aperture to expose for bright backgrounds while lighting your subjects with a flash head or two.

Metering & Focusing

Metering modes

Although modern DSLRs have intelligent light meters built in, certain lighting and backgrounds, the position of your subjects in the frame, and light or dark areas can sometimes fool your camera into producing inaccurate exposures. Most high-end DSLRs have the following metering modes, and it's vital to know which is best for each portrait style setup:

Evaluative metering (aka matrix or multisegment metering) is usually your camera's default mode. It works by measuring the light intensity in a number of different zones and combining the readings to produce the best overall exposure. This is helpful when shooting large groups of people or if your subject fully fills the frame.

Center-weighted average metering also takes a reading from the whole scene, but concentrates mainly on the central 60–70 percent of the frame. This is fine when your subject is central, but can become misled when the outside areas contrast vastly to the central subject.

Spot metering is the most accurate metering mode, as it takes a reading from a very small, specific area of the frame and assumes that this is midtone (around 2–4 percent). It is ideal for exposing for skin tones, and is great for high-contrast portraits, such as when your subject is backlit by the sun.

Stay focused

There are two main techniques to use when shooting in autofocus (AF) mode: manually selecting the AF point to focus on where your subjects are in the frame, or using Focus Lock to select the center AF point, holding down the shutter button to lock the focus on your subjects, and then recomposing your shot. Focus Lock is favored by most pros as it's faster and useful when focusing on an off-center subject not covered by an AF point.

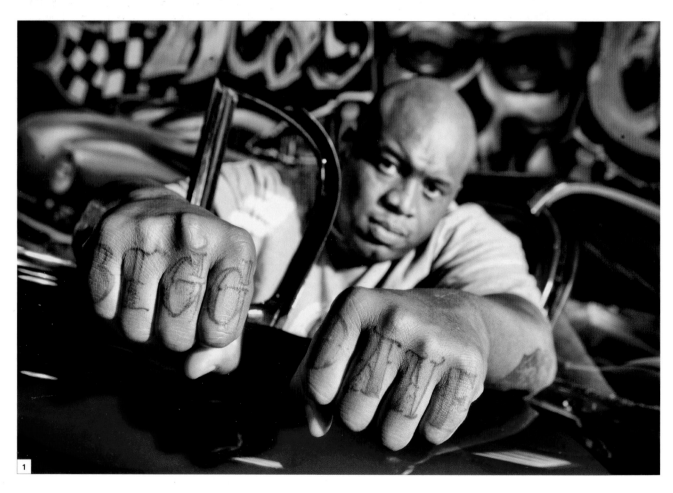

1 Accurate focusing skills are crucial when photographing people. Aim to focus on your subject's eyes for the majority of portraits, but for more inventive portraits focus on your subject's hands in the foreground.

Whichever method you use, make sure your focusing skills are up to scratch, as out-of-focus portraits won't pay the bills. For the majority of your portraits you'll want to focus on your subject's eyes, although our example of focusing on a subject's hands (below far left) shows that there are some exceptions to the rule.

ISO technology

The old school of thought was to keep ISO at 100 unless there was a good reason to increase it—for example, you might have bumped up ISO when shooting handheld in low light without flash in order to obtain a fast enough shutter speed, accepting that you would get noisy results. Thankfully, the days of unwanted grain ruining images at ISO 1600 or 3200 are long gone, and pro DSLRs today enable you to shoot at ISO 6400 and 12800 with minimal noise pollution (Canon's EOS-1D Mk IV and Nikon's D3s both top out at ISO 102400).

Having greater control at higher ISO settings also makes it easier to shoot portraits in natural light with a long lens when you want to avoid focusing and optical quality issues when wide open at f/2.8. With higher ISO, you'll be able to achieve a fast enough shutter speed at f/5.6, giving you sharper shots with a greater depth of field. Increasing ISO will also project the light spread even further, helping to lighten surroundings when using flash.

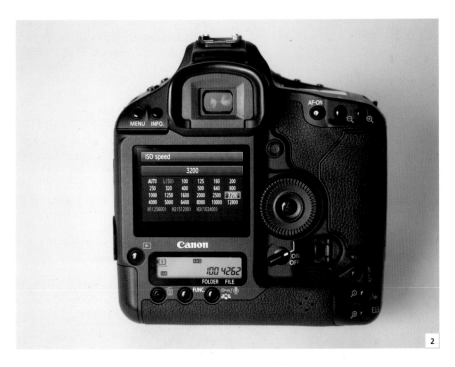

2 Modern pro DSLRs and their ISO performance has improved dramatically over the years. You can now shoot at around ISO 6400 with little noise or grain problems, which enables you to shoot successfully in very low light conditions without flash.

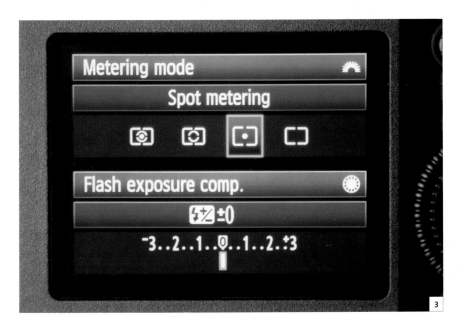

3 The metering mode you choose can have a big impact on your portraits. When exposing subjects with lighter skin tones, and in darker surroundings, use Spot Metering for more accurate results.

Studio Lighting

It's a well-known fact that the key to professional portraiture is good lighting. Natural light can produce terrific portraits (see pages 142–143), however you will always be a slave to the weather and won't be able to control the strength or direct the available light like you can with a good set of studio flash (aka strobe) lights.

By using flash lights, whether indoors or out, you are in total control of the lighting situation. You can place one, two, or three lights on stands, set the strength, and aim the light where you need it, attaching a softbox diffuser or honeycomb grid to produce shadows and highlights according to the portrait style you're after.

Two heads are better than one

There's nothing worse than flatly lit portraits—they look lifeless and one-dimensional. A single flash head can offer a variety of possibilities, but you'll get even better results using two or three lights to create shade, and therefore shape and form, giving your portraits added depth.

A good starting point is to position your subject against a dark backdrop. For your main (or key) light source, use a softbox on one light from the front-side to create an even light on one side of the subject's face. Use a honeycomb grid to focus light onto the back of their head to create a "rim light" around the other side of their face and hair, lifting them away from the background. You can also use a reflector here to bounce some light onto the side of their face that's in shadow, and could also bring in a third light with a snoot to lighten up the background behind them. There are endless possibilities when you introduce additional light sources, so it's a good idea to experiment with your kit and become familiar with the different effects they can produce.

1 It takes time and practice to learn how to set your lights to achieve the desired result, but with experience you'll quickly learn what settings work best for different portrait styles.

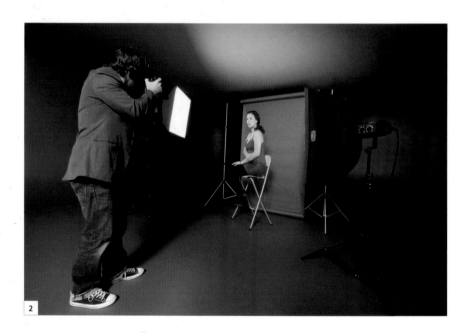

2 When learning to shoot with studio lights, a good place to begin is with two flash heads (with softboxes attached) positioned either side of your subject sat against a dark backdrop.

Softboxes, honeycombs, and umbrellas

Equipping your lights with different diffusers will allow you to create different lighting effects for different portraits. Softboxes come in a variety of sizes, usually square or rectangular, and the larger the softbox the softer and broader the spread of diffused light. Umbrellas are another type of diffuser, some of which are translucent white and can be used to diffuse flash light or bounce light back onto your subjects when turned around. Black umbrellas with silver linings are used purely to bounce light, and can also boost contrast.

Honeycomb grids are great for focusing light onto specific areas, either on your subjects or on your backdrops. Used along with a snoot they are ideal for creating a "hair light," for example.

Flash techniques

If used straight on as a direct light source, your flash will deliver a harsh light and create unflattering, distracting shadows. However, if you're pressed for time, space, or on a tight budget and only have a hotshoe flash on your DSLR, there are still ways to capture nicely lit portraits.

To produce flattering lighting you'll need to enlarge your flash's light spread, which will create softer light, and therefore softer shadows, and also reduce a "shiny skin" look. You can either angle your flash or use a reflector to bounce the flash light off white ceilings or walls, or there are a variety of flash diffusers available to help spread and soften the light for better results.

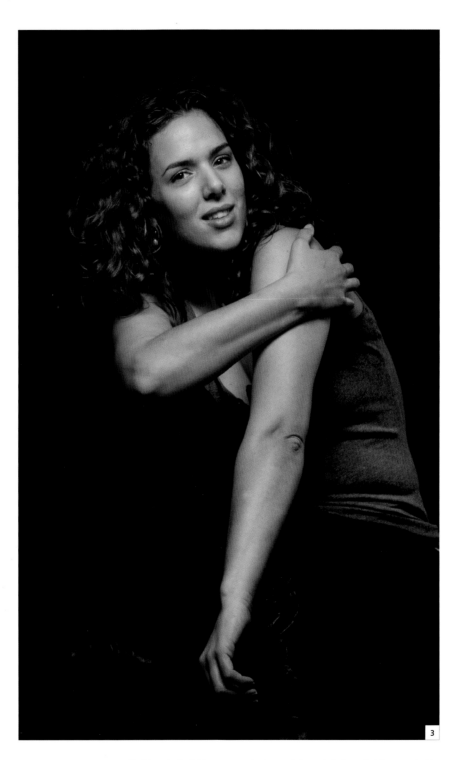

3 Using studio lights means you're in complete control of your lighting; you decide how strong or how subtle the light will fall on your subjects and how many lights to use, which diffusers, and the direction of lights.

Outdoor & Natural Lighting

Depending on your client and what portrait style you're shooting in, it's likely that half of your assignments will take place outdoors. This can introduce a number of new factors to consider, including the weather, accessibility, and mobile lighting setup. Important questions you need to ask yourself before tackling outdoor shoots include: can I work with the sun? Can the shoot continue if it rains or if light levels are low? How far is the location from where I'll be parking? Can I carry all of my lights and camera kit on my own? Which lights and diffusers will I need? Can I use two flashes on stands?

Using your environment

The significance of backgrounds should never be underestimated when shooting portraits outdoors. Where you position your subjects in relation to the background will also change the feel of the portrait—too far away and you won't be able to tell where they are; too close and the background will remain in focus and become distracting.

It's important to use what's available to its maximum potential on every shoot, whether it's a park bench, warehouse door, brick wall, a yard, or the sky. Very often you won't be the one choosing the location and you'll have to manage with whatever is available.

Also be aware of how background colors can dramatically change your portraits. For a softer portrait style choose muted colors, or if you're after a stronger, bolder portrait style go for primary colors.

Strobist photography

Strobist (or flash) photography is very popular, as it enables photographers to capture professional-looking portraits by simply using two or three flashes off-camera. This minimalist approach is simple, affordable, and very portable, making it ideal for semipros that need to hone their lighting skills.

Start off by simply using one flash attached to your DSLR via a sync lead. Hold the flash at arm's length up and to the side of your subject to create creative side lighting. By

using infrared or radio transmitters your DSLR can fire each flash remotely, or you can use the flash attached to your DSLR as the main unit that can then fire the slave units. Use the latter to provide side lighting or back lighting, or you can bounce these units off ceilings or walls to create diffused light for softer results.

One of the great advantages of flashes is that they incorporate the TTL (through the lens) flash exposure system, enabling you to shoot quickly in semiauto Tv or Av modes when time is short.

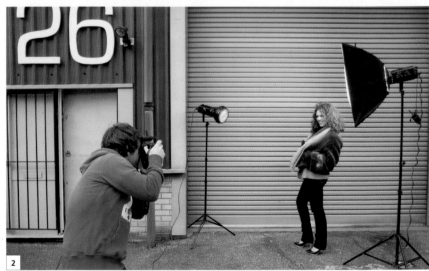

1 & 2 When shooting outdoors you'll be faced with many possibilities (and challenges) for capturing creative portraits with or without lights.

Natural light

Of course, you don't always need artificial light; you can go back to basics and use available or natural light to capture great portraits too. If you're working outdoors, it's best to try and shoot at the start or end of the day when the sun is lower in the sky and the natural light is softer, which makes for more flattering portraits.

If you do need to shoot outdoors in the middle of the day when the sun is directly overhead, shoot in the shade, which will help to avoid unpleasant shadows on your subject's face. Shooting in the shade under a large tree is a great method, as the sunlight gets diffused as it passes through the leaves.

Better still, shoot outside on overcast days to avoid glaring sunlight.

When shooting indoors with natural light, position your subject near a window, once again avoiding direct sunlight that will create harsh shadows. The bigger the window, the bigger the spread of light, which means softer shadows and better portraits. This is why softboxes are so big—they help spread the light, and effectively recreate natural window light.

Reflected light

Whether shooting indoors or outdoors in natural light, it's a good idea to use a reflector to bounce some light onto the side of your subject's face. Use a white reflector to brighten up your subjects or a gold reflector to warm up skin tones.

3 When you're shooting portraits on location, learn to utilize whatever backgrounds or props are available—a wooden bench, a brick wall, a hay bale, or even the sky—to add context and drama to your shots.

Creative Composition

Composition is an essential element in any successful image, especially portraits. Where you position yourself in relation to your subjects, their position in the frame, their eyeline—the possibilities are endless. Below you will find some winning professional techniques that are sure to improve your portraits.

Viewpoint

The angle of view, or your viewpoint, will have a dramatic impact on your images. With your subject in position, don't just stand there and take the shot; at the very least get down to their eye level. Try moving around, crouching, kneeling down, and even lying down to find more creative angles of view.

Don't forget to direct your subject as well. Have them turn their body 45 degrees then look toward you for more interesting body shapes. Have fun and try all types of angles.

Eyeline

The same goes for the direction of your model's eyes or their eyeline. This can significantly change the emotion of the portrait for better or worse. When positioning your subjects in the frame don't simply position their eyes central to the frame unless you want a neutral, passport-style photo. Positioning your subject's eyes in the top third of the frame will make them look more dominant, while positioning their eyes in the bottom third will make them look

more submissive. You can also get them to tilt their head down then look up at you, or turn their head slightly then look back at you.

Positioning your subject

Give your subjects some breathing room in the portrait. By shooting your subject from the waist up, then positioning them one third into the left or right of the frame, it will offer them more space and give the portrait an artistic feel. This technique works particularly well if your subjects are looking off to one side. Compose your shot so that they're positioned to one side and "looking into the space," as this will draw people's attention into the portrait.

1 Your position and your subject's position will have a great influence on your results. To add an air of authority, for example, get down low so that they look down at your camera.

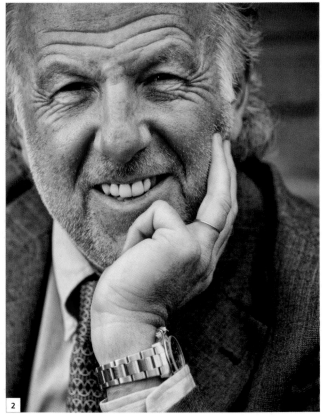

2 Your subject's eyeline, and where it's positioned in the frame, will also give your portrait compositions a different feel.

Rule of thirds

The "rule of thirds" is another important compositional technique. Break your images down into thirds with imaginary lines vertically and horizontally drawn at a third and two-thirds across the frame, then position your subject's head or eyes at the intersections. Use your camera's autofocus points to focus on your subject's eyes.

3 & 4 Don't be afraid to get creative with your compositions. Positioning your subjects to one side and using a blank background will give them space to breathe, or cropping off the top of their head can add a sense of intimacy.

Reviewing Your Shots

One of the many benefits of modern digital camera technology over film photography is the ability to instantly and accurately review shots on your high-resolution color LCD, however there's more to it than quickly glancing at your images on screen.

An obvious but important point is that it is good practice to make sure your LCD is calibrated correctly to avoid any inaccuracies. Be aware that your LCD will also appear brighter when shooting in a dark studio compared to outside in broad daylight.

When reviewing shots on your camera's screen, carefully check your composition to see if it can be improved—are there any distractions in the foreground or background that can be removed with better framing? Can your subject's position in the frame be improved? It's also good practice to zoom in on your subject's face when checking shots on screen in order to ensure your focusing is spot-on and your shots are sharp. All of these checks will save you time when it comes to processing your shots.

Histograms

Histograms are graphs that reveal the tonal range of an image. On the horizontal axis darker tones appear on the left, midtones in the middle, and lighter tones on the right. The vertical axis shows the amount of pixels for each of the tones. When reviewing your portraits mid-shoot, histograms are invaluable for checking your exposures. You can immediately see if the shadows or highlights are clipped, indicated by data falling off the ends of the graph on the histogram. This means that detail will be lost in the darker or lighter areas of your shots.

When reviewing your shots on camera use the brightness histogram to check the tonal range, overall brightness, and gradation. You can also switch on the RGB histogram to check the color and saturation levels.

Most DSLRs have a "highlight alert" option, which will make overexposed areas blink on the LCD, warning you that you may need to adjust the exposure. Of course, if you are

shooting a portrait with lots of light tones (a blonde-haired model wearing white against a white backdrop with a multilight setup, for example) or dark tones (a dark-haired model against a black backdrop with a single light setup, for example), then clipped highlights or shadows will be desirable.

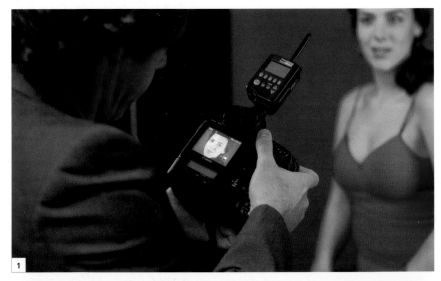

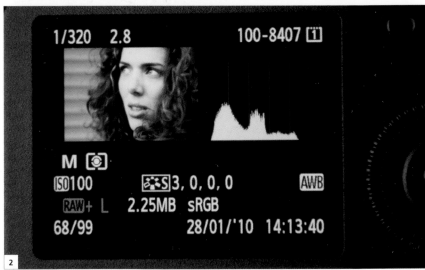

1 & 2 When reviewing your shots, be quick to check that your focusing is good and whether your composition or your subject's pose and expression can be improved. Also learn to use histograms to check that your exposures are accurate.

Bracketing exposures

Although bracketing exposures is an SLR technique more commonly associated with film cameras, it can benefit the DSLR photographer when it comes to shooting in difficult weather conditions. It's a great way to shoot outdoor portraits, as you can expose for your subject as well as for background highlights and shadows, and then put them together like you would with an HDR composite image.

Set your camera up to bracket your exposures (one standard exposure, two or three stops underexposed, two or three stops overexposed), using a tripod to keep your camera in exactly the same position. Ask your subject to keep as still as possible, and shoot away. If you use your DSLR's continuous shooting mode, you can press the shutter button once to quickly burst off three bracketed shots. Simply merge the three exposures together in Photoshop using layers and masks, bringing out your subject and the light and dark details in the background and foreground.

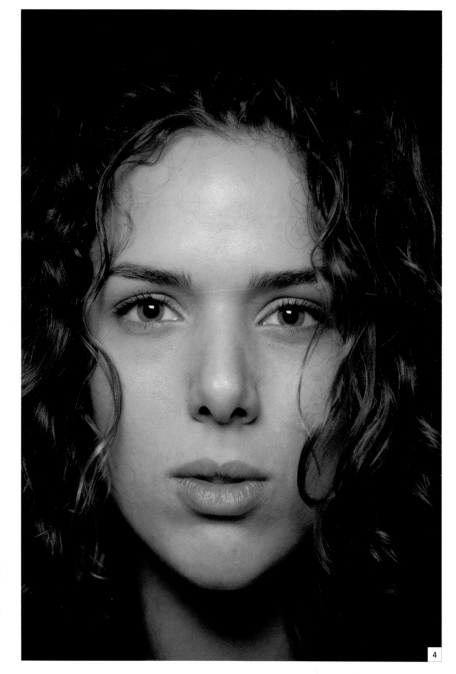

3 Histograms are helpful for quickly showing you the tonal range of your images. Shadows are on the left, midtones in the middle, and highlights on the right.

4 When shooting creative portraits that include dark areas (the background and the model's hair, in this example), it's perfectly acceptable for your darker tonal information to become "clipped" off the left edge of the histogram.

Equipment

They say it's not the camera that takes great photos, but whoever's operating it that counts. While this is true, it's also true that the difference between professional and amateur-level DSLRs, lenses, and lighting equipment can be the difference between capturing the occasional half-decent portrait and being able to rely on your kit to capture top-class portraits, day in, day out, regardless of the shooting conditions.

Like many things, when it comes to photographic gear you get what you pay for. Buy cheap and you'll buy twice. To those starting out in the professional arena, the cost of all this kit may seem extortionate, however try to look at it as an investment. You're investing in your future and in your business. Like all good investments, in good time your pro gear will end up paying for itself tenfold.

In this section we cover all of the kit you'll need to be able to confidently capture professional portraits. We look at the benefits of top-end DSLRs and why it's important to invest in a decent set of lenses, including fast wide-angle and telephoto zooms.

We explain what you should consider when buying lighting equipment, plus all of the gadgets and gear that can help make your life easier as a hard-working professional portrait photographer.

DSLRs

Which SLR camera you choose to take portraits with will have a big impact on your results. Although some pros still prefer film, digital camera technology has improved dramatically over the last few years and the majority of photographers now use DSLRs. As a result, this section concentrates on DSLRs and the benefits of investing in pro-level kit.

Pixel power

The bigger your camera's sensor, the more pixels it can capture—and more pixels means higher image quality (or resolution). Many amateurs get blinded by megapixel power and think more megapixels means better images, when in fact more only really means bigger images. While the majority of DSLRs over 10 megapixels will be big enough for most professional portraiture (fine for A3/tabloid-size images, for instance), top-end pro cameras now come equipped with over 20 megapixels, such as the 21 megapixel Canon EOS-1Ds Mk III and 24.5 megapixel Nikon D3x.

The crop factor

The next important point to consider is your chosen DSLR's sensor size. Amateur/semi-pro DSLRs generally have Advanced Photo System type-C (APS-C) size sensors, which have a crop factor (aka a focal length multiplier) of around 1.6x or 1.5x. This means the 35mm film equivalent focal length is approx 1.6x times the lens focal length. For example, an 18–55mm lens on a DSLR with a crop factor of 1.6x has an actual focal length range of 29–88mm.

Crop factor can be advantageous for motorsports or wildlife photography, for instance, when you want to get closer to your subjects for more intimate shots, as a 300mm focal length of 1.6x becomes a whopping 480mm. The disadvantage is that your wide-angle lens won't be as wide—for instance, a 24mm focal length becomes 38mm, which can be problematic for portraiture, especially when working in tight spaces indoors where there isn't any room to stand back to fit your subject(s) into the frame.

Full-frame sensors

Pro-level DSLRs have what are known as "full-frame" sensors, which means that they have an equivalent-sized sensor as 35mm film, and have zero crop factor.

Being able to capture larger, higher resolution images means you will be able to print your images bigger without losing image quality—plus, if you need to severely crop one of your portraits taken on a full-frame camera, the resulting smaller, cropped image will still be high enough quality to print.

A further benefit of full-frame DSLRs is that, because of their higher spec sensors, they offer better high ISO performance—even at ISO 1600–6400 and above you'll notice minimal noise ruining your portraits. This is where lower spec amateur-level DSLRs tend to struggle—another reason why it's worth investing in pro kit.

1 Pro DSLRs are equipped with bigger, higher resolution color LCDs for checking your settings and reviewing your exposures quickly and accurately.
2 For greater control and better all-round results it's good practice to shoot in your camera's highest RAW image quality setting.
3 Canon and Nikon are the two big names in pro camera kit; both produce powerful, high-end and dependable DSLRs ideal for professional portraiture.

Image processing

What's equally important is the processor that determines how quickly your DSLR starts up and reads, processes, compresses and writes image data to your memory cards. Faster processors are able to keep the "buffer" clear during continuous shooting bursts. When shooting multiple portraits, for example, once you hit the buffer your camera pauses while it processes the images. How fast your processor works can be the difference between capturing and missing the shot.

Pro DSLRs generally have faster processors, which will mean minimal disruption when shooting. The best DSLRs have dual processors, which ensure accurate colors and white balance, even in challenging lighting conditions.

Build quality

Another major advantage of pro DSLRs is their superior build quality. These DSLR bodies are usually made of robust magnesium alloy and will shrug off any knocks when you inevitably drop or bang your camera. Cheaper plastic amateur DSLRs are likely to break and stop working; not good during an important shoot. Pro camera bodies also have better dust and moisture-resistant sealing to protect them from the elements and to combat the wear and tear of daily use.

Large LCDs

DSLRs with a large rear LCD (Liquid Crystal Display) also help pros get the job done quicker. A large (around 3in/7.5cm), clear, color, and, most important of all, high resolution (around 920k dots) LCD enables you to promptly and accurately review your portraits—you will instantly know whether you need to brighten or darken your exposures, for example.

Most pro DSLRs now also offer "live view," which enables you to see what you're shooting on the LCD to perfect your compositions and exposures. This is especially helpful if you're positioned close to the ground, as you'll be able to frame your shots via the LCD rather than struggling to stoop down to the viewfinder.

Bursting with benefits

Another benefit of choosing a pro DSLR is more accurate and responsive autofocus (AF) systems, with more choice of AF points (anything up to 45 AF points compared to an amateur DSLR's 9 AF points), and more advanced metering systems.

A faster "burst" mode (anything from 5–10fps, capturing continuous bursts of anything from around 50 to 130 JPEGs in one go) can also be helpful when you're under pressure and need to take multiple images to ensure you get the shot.

Finally, pro DSLRs are a pleasure to handle. They're usually equipped with dual shutter buttons (on the top and side), for example, making it quick and comfortable to switch from shooting horizontally to vertically.

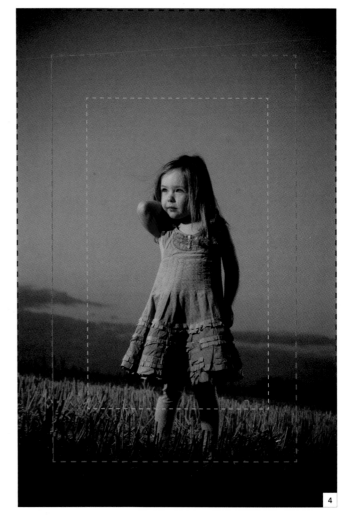

4 Above is an example of crop factor. The black lines show a full-frame sensor (approx 36 × 24mm); red shows the APS-H sensor (approx 29 × 19mm); and orange the APS-C sensor (approx 22.5 × 15mm).

Lenses

Your camera is only as good as your lens, so don't make the mistake of attaching any old lens to your DSLR and expecting it to capture great portraits. High-quality lenses not only focus more quickly and accurately, they also produce consistently sharper results at all apertures and focal lengths, plus they're more robust when it comes to daily professional use.

We'll now look at the different lenses you'll need for portraiture photography and the benefits of investing in a high-quality set.

Telephoto zoom lenses
Many people find it intimidating to have their photo taken. If you're right up close with a 50mm lens, people are unlikely to relax and you're unlikely to get good results. By using a telephoto zoom, such as a 70–200mm f/2.8 lens (pictured below right), you'll be able to stand a few meters away and give your subject some space. This will help them feel more comfortable, and because of the telephoto lens, you'll be able to fill the frame, creating a more striking portrait.

Telephoto lenses (with focal lengths of 70mm and above) have the added advantage of capturing a shallower depth of field compared to "standard" focal length lenses of 35mm or 50mm at the same aperture. This is especially noticeable at wide apertures of around f/2.8–f/4. A shallower depth of field means you can easily drop backgrounds out of focus (aka bokeh), making your subjects stand out in the scene.

Using a telephoto zoom lens gives you the ability to compress distances (especially at longer focal lengths of 200mm or above) and pulls elements in your shots closer together. Telephoto zooms also allow greater scope to quickly capture a sequence of different portraits with more or less of your subject in the frame, all without you or your subject needing to move out of position.

Choosing the right zoom lens
Whether investing in a 16–35mm, 24–70mm, or 70–200mm zoom lens for portrait photography, it's best to choose a high-quality lens with a fast, constant aperture of f/2.8. Being able to use the same wide aperture throughout the zoom range will ensure your exposures remain constant, whatever the focal length. It also means you can achieve consistently faster shutter speeds when shooting in low light without flash.

Wide-angle lenses
Wide-angle lenses—any lens with a focal length shorter than 35mm—offer a wider angle of view, making them useful when you need to fit a lot into your frame. Wide-angle lenses can accentuate people's facial features. This can help you to produce edgy and creative portraits, but be aware that shots taken with an extremely wide focal length lens (such as an 8mm fish-eye lens) may not be the look your client is after.

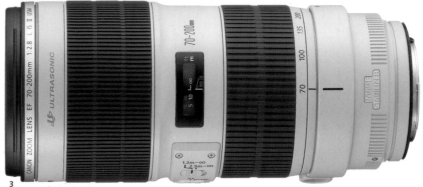

1 & 2 Telephoto lenses are useful tools for portraiture. They capture a shallower depth of field, so backgrounds can be blurred to draw more attention to your subjects.
3 A pro-level 70–200mm f/2.8 telephoto zoom lens offers an ideal focal length range for portrait shoots.

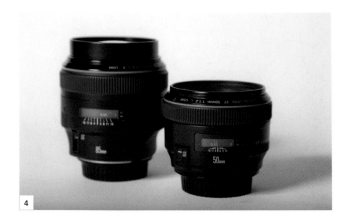

4

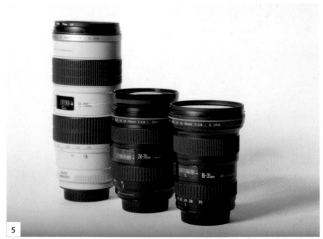

5

6

The opposite is true when you use telephoto lenses, as they "compress" whatever is in the frame, which can help to flatter facial features.

As they naturally offer a greater depth of field, wide-angle lenses are perfect when you want to get more of your subject and their surroundings in focus and in frame. This is a good technique when shooting editorial portraits and you need foreground or background detail in shot to help tell the story.

Optimum apertures

All lenses have an optimum range of apertures, which will guarantee the sharpest results. They're usually between around f/8 to f/16, but test your own lenses to work out which apertures produce the sharpest results. Even when pro lenses are wide open (f/2.8) or fully closed (f/22), there may be a slight drop off in sharpness around the edges, and possibly some vignetting (darkening at the corners) when using wide apertures.

Prime lenses

It's a good idea to have a fast prime lens or two, such as a 50mm f/1.4 or 85mm f/1.2, in your kit bag to cope with very low light situations. Prime (fixed focal length) lenses also offer optimum lens quality, because unlike zoom lenses there are no moving parts, which can sometimes affect image quality.

4 & 5 Many pros prefer the superior quality and simplicity of prime lenses (image 4), but zoom lenses (image 5) offer more options when space and time is tight. Invest in a set of zooms that cover the focal lengths you'll need, such as a 16–35mm, 24–70mm, and 70–200mm.
6 Shooting with a wide-angle lens (15mm in this example) will allow you to fit more of your subject's surroundings in shot.

Image stabilization

The majority of pro lenses now come equipped with image stabilization (IS) technology. This can help you to achieve sharp shots even at shutter speeds normally too slow to shoot handheld. IS can be especially helpful when shooting in low-light conditions and, for whatever reason, you're unable to use lights.

Lighting

Whether you're an ardent amateur or an up-and-coming professional, and whether you shoot mainly in studios or on location, taking great portrait photos requires a good set of lights. Continuous lighting is normally used for video work or static subjects, but for portraits you're better off with flash (aka strobe) heads, which provide short, powerful bursts of illumination.

Heads up

Rather than buying just one flash head and therefore restricting your photography, it makes more financial sense to invest in a two- or three-head studio lighting kit. With this type of light setup you'll have far more control and choice, enabling you to capture the vast majority of portrait styles in this book. If you find you regularly need a fourth or even fifth flash head, and possibly a ring flash, then you can add these to your kit later on. (See page 140 for more on the advantages of using multiple flash heads.)

Kitted out

The set of lights you invest in will depend on your budget and what stage you're at in your portrait photography career. Reputable lighting manufacturers such as Bowens and Elinchrom offer a range of quality lighting kits from affordable entry-level to more expensive pro-level kits. For lower-budget options consider Speedotron or Interfit, while at the higher-end brands such as Hensel and Profoto produce kit designed to withstand the rigors of continued daily use. Most kits come with heads, power leads, cables, sync leads, and stands.

I've got the power

Lighting power is measured in watt-seconds (Ws or joules), varying from around 200Ws to 3000Ws. The amount of power will be reflected in the price, but the more power you have, the more flexibility there is to diffuse and spread the light. For most portraiture 400Ws is powerful enough, unless you're regularly shooting in huge open spaces and with narrow apertures.

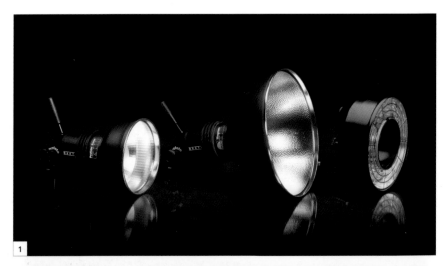

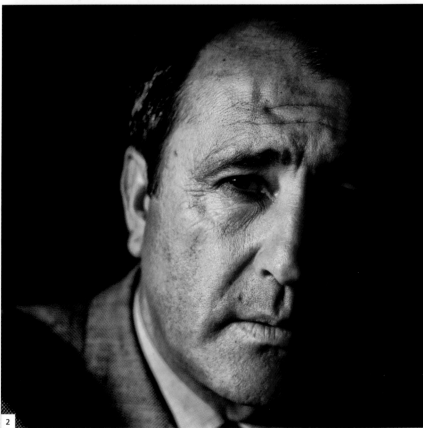

1 It pays to have a range of different flash heads in order to give you more creative control over lighting.

2 A good set of studio lights will enable you to consistently capture professionally-lit and powerful portraits.

A manual power range of five stops—from full power down to ⅟₃₂nd of full power—is also fine for most applications (pro kits will regularly have a 7 stop range). A built-in "modeling light" also comes in handy when positioning your lights between firing, as it gives you a preview of the lighting effect on your subjects.

Be aware that the more powerful the lights, the bigger and heavier they are, and therefore the less portable they will be—some high-powered lights even come with an additional hefty power pack. If you do a lot of location work far from an electrical power source, consider investing in portable, battery-powered lights.

Light controls

If your lighting kit doesn't come fully equipped you'll also need to invest in a good variety of light controls and diffusers for your flash heads—one square softbox (24 × 24in/ 60 × 60cm or 40 × 40in/100 × 100cm), one (translucent white) umbrella, and one honeycomb grid and snoot at the very least. Ideally, two or three of each (including a rectangular softbox around 55 × 40in/140 × 100cm) will give you more control and options on shoots. It's also worth getting a selection of color gels for creative diversity. It's far better to have the kit with you when it comes to the crunch on a challenging shoot than just wishing you did.

Gadgets and gizmos

Within your kit you'll get a sync lead to link your lights to your DSLR via its PC sync socket (amateur DSLRs are unlikely to have a PC sync socket). While this is fine, being tethered can be restrictive, and there are so many great wireless triggers available that can attach to your DSLR's hotshoe to give you more freedom; especially useful when shooting outdoors.

Your lighting kit manufacturer will offer its own radio-controlled triggers. It's worth investing in some PocketWizard radio triggers, which are generally considered to be the best as they offer so much control and work over the biggest range (up to 200m/656ft).

On a budget?

If you're not ready to buy an expensive pro lighting kit, why not first consider hiring a studio with lights, factoring these costs into your fee? This will allow you to try out different flash lighting brands and see which lights best suit your needs.

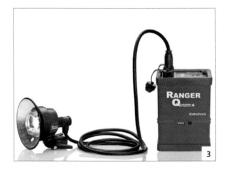

3 If you regularly shoot on location it's a good idea to get yourself some portable battery-powered lights.

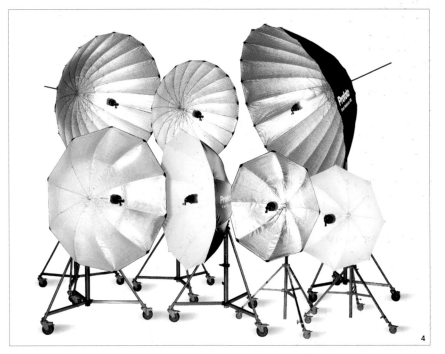

4 Investing in a good selection of lighting controls and diffusers will enable you to soften and direct the light according to the portrait style you're shooting in.

Backdrops & Essential Kit

As a portrait photographer you'll need to have a range of different backdrops, so it's a good idea to build up a collection of colored paper rolls for this purpose. Brands such as Lastolite, Savage, and Colorama produce crease-free rolls in various widths, from 4½ft/1.35m to 11½ft/3.55m, to suit different portrait setups. Roll lengths vary from 36–98ft/11–30m. When the paper gets dirty, simply cut it off and unravel a new section.

Keep half-rolls (5½ft/1.72m wide) in the trunk of your car for location shoots, and use bigger rolls in the studio for wider compositions, such as family portraits. Also consider using muslin or fabric backdrops—check out brands such as Backdrop Alley and Botero. You'll also need stands to hang up your backdrops. Most lighting manufacturers make them, so pick stands to suit the height of your studio. Portable stands are ideal, as you can also use them out on location. Permanent wall-mounted systems are better for large-width rolls—Manfrotto make some sturdy, permanent holders.

A question of color

Think about what color backgrounds you will need. You'll definitely need white, and perhaps royal blue, light green, and dark red, depending on the portrait styles you're shooting in. Smoky gray is also popular with clients looking for clean, contemporary portraits. Remember that you can always direct more or less light onto backdrops to brighten or darken them. Experiment with your lights to see how they react to different colored backdrops.

For a true black backdrop you will need to use a velvet (or velour) fabric sheet, as it absorbs the light to produce an even, rich black tone. Lastolite's collapsible 5 × 6ft/1.5 × 1.8m black velvet background comes with a five-piece stand, and is ideal if you regularly need a portable black backdrop for location shoots.

1 Think carefully about your background choice and color, as this can dramatically affect the look of your portrait.
2 Regularly invest in new colored backdrop rolls to build up a collection.

Textured backdrops

You can get textured and patterned backdrops of all different surfaces and types, although we'd recommend avoiding fake canvas skies, as your portraits may also end up looking fake.

If you're kitting out your own studio, consider exposing the brickwork on one wall (if possible), making it suitable for gritty urban portraits.

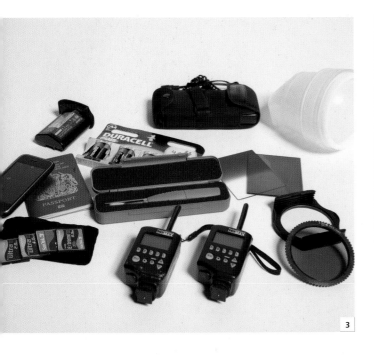

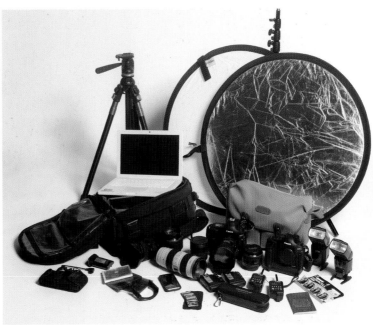

3 & 4 As a professional photographer there is a lot of essential photographic gear you'll need to do your job effectively. Try to look at the initial expense as investing in your career and future.

Essential kit

Here is a list of indispensable kit for the professional photographer:

Camera backpack and day bag
Sturdy tripod
Collapsible reflectors
Neutral density and neutral density graduated filters
Circular polarizing filter
Gray card
Spare memory cards
Lens cloth
Spare camera batteries
Flashes

Battery pack for flashes
Batteries for flashes
Flash diffuser
Radio flash triggers
Infrared flash triggers
Sensor cleaning kit
Portable hard drive
Laptop
Cell phone
Passport

Photoshop Tutorials

Digital cameras revolutionized the way we take photos and the digital darkroom revolutionized the way we process them. Thanks to powerful image-editing software such as Photoshop, very sophisticated photographic developing and manipulation techniques can be replicated with a few simple clicks of a mouse. However, Photoshop should only be used for enhancing a good image in order to make it great, not for rescuing a bad one.

As a professional portrait photographer it's essential that you develop your Photoshop skills for processing your shots quickly and effectively. With our help, you'll be able to produce images exactly how you, and more importantly, how your clients, visualized them.

In this section we'll guide you through some key portrait photography image-editing techniques with easy-to-follow, step-by-step tutorials. We'll reveal the powerful advantages of processing RAW photos, how to improve your exposures with Adjustment Layers and the Levels command, and how to make quick HDR images.

We'll also look at retouching techniques that will give your portraits a digital makeover, including using Curves to lighten skin tones and the Clone tool to clean up blemishes, plus how to combine your portraits with a different background, and the best way to approach black-and-white conversions and sharpening.

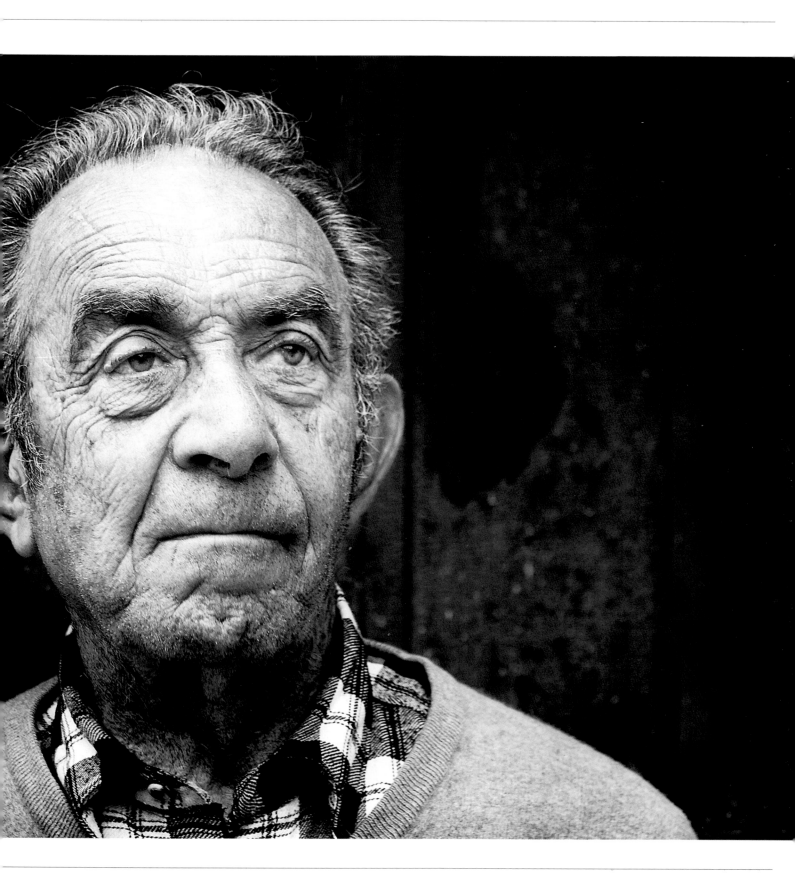

RAW Processing

Professional photographers shoot in RAW as it is the highest-quality image setting and provides more control when it comes to image processing. RAW files are like digital negatives; they retain the maximum amount of picture data.

As RAW files contain uncompressed and unprocessed picture data, you need to process them into workable TIFF or JPEG files. Adobe's Camera Raw software (which comes with Photoshop) is a powerful program used for processing RAW files quickly and precisely. When you make adjustments to RAW images the original data is preserved (so you can always revert back), and the adjustments are stored for each image as metadata embedded in a "sidecar" XMP file.

In Camera Raw you can push your RAW images up to 4 stops to recover under- or overexposed detail, and white balance can be altered from 2000–50,000k to cool down or warm up portraits. In this tutorial we will also look at how you can recover overexposed areas when brightening your shots, how to add fill light and darken shadows, and how to adjust clarity, saturation, and vibrancy.

This Camera Raw overview will help you to integrate tried-and-trusted RAW processing techniques into your standard post-shoot workflow.

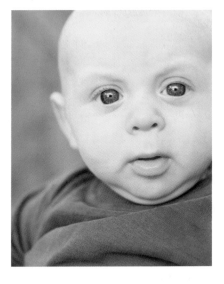

Before

After Image by Peter Travers

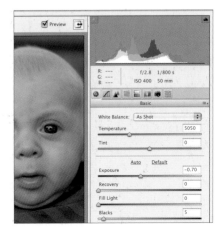

Step 1. Opening your RAW file in Adobe Photoshop automatically takes you to the Camera Raw workspace, where you can correct or adjust the white balance (WB). Regardless of what WB setting you were using when you took the shot, you can cool your portrait down (below around 4000k) or warm it up (above 6000k). You can also use any of the presets including Daylight, Shade, and Fluorescent Lighting.

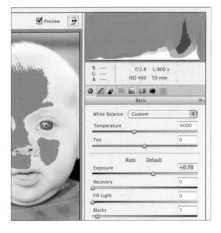

Step 2. In the top right corner is your image's histogram, with the overall tones shown in red, green, blue (RGB), and white. It's good practice to click on the two arrows above the histogram to switch on the Highlight and Shadow Clipping Warnings. Any clipped highlights will appear in red and clipped shadows in blue.

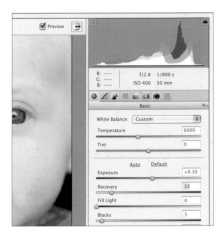

Step 3. Use the Exposure slider to adjust the overall brightness of your RAW image. You can increase (brighten) or decrease (darken) your exposure in equivalent f-stop increments (up to 4 stops). If you start to clip any highlights when trying to brighten your subject's face, for instance, drag the Recovery slider up until the red clipped warning disappears.

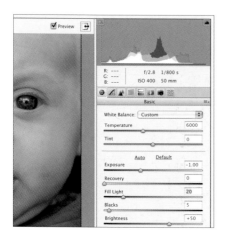

Step 4. Alternatively, if you start to clip any shadows in darker areas of your image when decreasing your exposure, you can use the Fill Light slider to attempt to recover detail from the shadows without brightening the black tones. Drag the Fill Light slider up until the blue clipped warning disappears.

Step 5. If you need to brighten just the midtones of your images without touching the shadows or highlights you can use the Brightness slider. You may need to readjust the Exposure and Recovery sliders after this. If you need to boost the overall contrast of the midtones, again without affecting the shadows or highlights, you can use the Contrast slider.

Step 6. If you need to adjust the color saturation of your RAW portraits it's best to use the Vibrance slider, as it aims to prevent skin tones from becoming oversaturated. Clipping is also minimized when colors approach full saturation, as it mainly affects the lower-saturated colors rather than overcooking the higher-saturated colors.

Step 7. It'll save you time, and reduce your JPEG image sizes later, if you crop your images at the RAW stage. Grab the Crop Tool from the top bar, set your ratio (1:1, 2:3, 3:4, 4:5, 5:7), and crop away, tilting your selection for a creative crop if necessary. The Retouch Tool, which is very powerful and adaptable, is also worth using to clean up blemishes.

Step 8. To save time you can also batch process multiple RAW portraits (of the same subject shot with the same lighting) by duplicating your enhancements.

Step 9. To make finite adjustments to your first image, select all of the images in the left-hand thumbnail view and click the Synchronize button above. Here you can also customize which adjustments to copy or not. When you've finished your RAW processing, click Open Image/s to open it/them in the full Photoshop workspace.

Adjustment Layers

However experienced you are as a photographer you will invariably need to enhance your portraits in Photoshop. In the days of the traditional darkroom there were hands-on techniques, but today Photoshop provides us with software tools that replicate these traditional techniques. The problem with these digital tools, however, is that every time you apply a change to your image in Photoshop you are degrading the original file and reducing its overall pixel quality.

Using Adjustments Layers in Photoshop, you are able to make changes without affecting the original image (or background layer). Every layer that you create sits on top of your original image like a transparency and enables you to experiment with different non-destructive enhancements. So if you make any mistakes or change your mind, you can simply revert back to your original image.

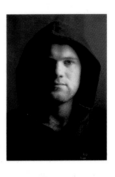

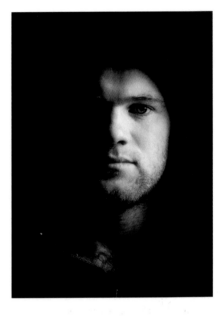

Before

After Image by James Cheadle

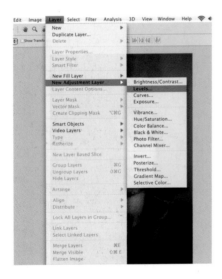

Step 1. I was after a dark and moody look when taking this portrait of Manchester United and England footballer Wayne Rooney. Although this was mostly captured in camera, I needed to make a few more tweaks in Photoshop to fully achieve the intended style. In order to replicate the enhancements you will need to create a Levels Adjustment Layer. To do this go to Layer>New Adjustment Layer>Levels.

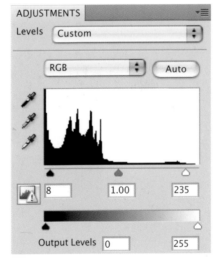

Step 2. Photoshop will create a new layer for you called Levels 1. Click OK and the Levels dialog box will open. To boost the contrast, darken the black areas by moving the Black Point slider to 8, and lighten the white areas by moving the White Point slider to 235, and then press OK. You'll notice in your Layers Palette that there will be two layers—the original Background Layer and the Levels 1 layer. To see the before and after effects of your Levels click the eye icon next to Levels 1 layer.

Step 3. To make adjustments to the tonal range in Curves you will need to create another Adjustment Layer. Go to Layer>New Adjustment Layer>Curves. Photoshop will call this layer Curves 1. Click OK to open the Curves dialog box—you will now have a third layer in your Layers Palette.

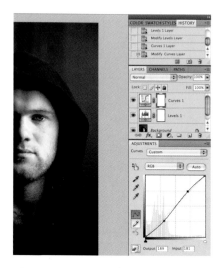

Step 4. To give the image a richer contrast you can create a small S-curve by selecting two points at roughly one third and two thirds along the line. In this instance we dragged the first point down a fraction and the second point up a fraction. When you're happy with your result click OK. If you need to tweak any Adjustment Layers you've created, simply double-click on them in the Layers Palette.

Step 5. The next adjustment we need to make is to darken the background behind Wayne's head. To do this, create a Duplicate Layer. Ensure that the Background Layer is highlighted in the Layers Palette and go to Layer>Duplicate Layer and click OK.

Step 6. To darken the background, select the Burn tool from the toolbar on the left. Set the Brush Size to around 1500 pixels, Range on Midtones, and, as it's best to build up slowly when burning your images, set an Exposure strength of 40–50%.

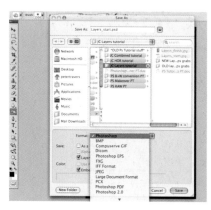

Step 7. You can use the Burn tool to carefully darken the background by brushing over the desired area while holding down the mouse button. Try to make broad, smooth brush strokes off to the edges of your image. Press Apple/Ctrl + Z to undo any erratic burning.

Step 8. You can also fine-tune your adjustments using the Opacity and Fill sliders on the Layers Palette. To adjust the Duplicate Layer slightly, highlight the layer and use the Opacity slider to increase or decrease the adjustments until you have achieved the desired look. This will only affect the Burn tool adjustments on the background of the Duplicate Layer.

Step 9. Now you've finished editing your image you will need to save it. You have two options. Saving the image as a JPEG will flatten all of the layers into one, losing access to the individual layers for future editing. If you feel you may need access to all of the layers you've created at a later date then it's advisable to save the image as a Photoshop (.psd) file instead.

Digital Makeover

However well you expose or light your subjects, and no matter how little or how much makeup a model applies, you'll need to retouch portraits from time to time to give them a professional finish. Every portrait can be improved, even if only subtle enhancements are needed.

Giving your portraits a digital makeover takes a combination of clever Photoshop skills. You'll need to learn how to improve skin tones, remove blemishes and bags under eyes, and soften unwanted character lines. It's also useful to learn the best methods for brightening your subject's eyes and teeth, and how to selectively increase the color saturation of their lips and other features.

In this tutorial we'll provide techniques that cover all of the above, allowing you to dramatically boost your portraits and give them a professional look and feel.

Before

After Image by Peter Travers

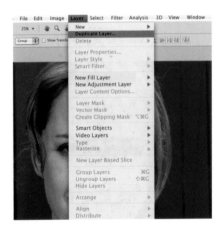

Step 1. This portrait was shot outdoors and lit with an off-camera flash (strobe), but it could do with a lift and overall makeover. Digital cameras tend to underexpose light skin tones in full-face portraits, so if you didn't adjust your exposure for the shoot you'll need to do so at the post-processing stage. Start off by duplicating your Background start layer (go to Layers>Duplicate Layer) and call the new layer Makeover.

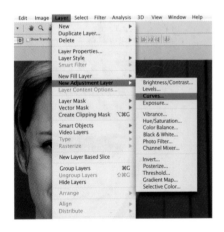

Step 2. To lighten skin tones in Photoshop go to Layer>New Adjustment Layer>Curves and call your new layer Curves 1. Curves work by altering the tonal range of your images depending on the curve you create. Drag the line up to lighten your image, drag it down to darken it, and an S-shape Curve will both darken shadows and brighten highlights to boost the contrast. For this image we lifted the curve up to brighten the subject's skin tones.

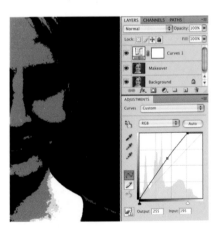

Step 3. To avoid clipping (overexposing) the highlights, hold down the Alt key (making the Curves graph and your image go black), and then drag the White Point Slider in. Any clipped highlights will appear in red, yellow, or white, depending on how clipped they are. Move the White Point Slider back until there are no red areas appearing on the graph, then let go of the Alt key to review your handiwork. Click OK once you're happy.

Step 4. Removing blemishes is an essential Photoshop skill for portrait photographers. To do so, select your Makeover layer and zoom in to 100% view to get in close. Select the Clone tool from the toolbar, choose a soft brush around 100 pixels, and set Mode to Normal and Opacity and Flow to around 50% to build up your cloning. Move your brush over an area of clear skin near the blemish, hold down the Alt key, click your mouse to clone it, and then paint smoothly over each blemish.

Step 5. Many people have bags or dark lines under their eyes, and if your subjects haven't worn (or don't wear) makeup, it's advisable to retouch these areas so they don't look overly tired. Again, use the Clone tool to repeatedly clone the smoother areas of skin under the bags to clean up—and wake up—your subjects.

Step 6. In order to brighten your subject's eyes and bring your portrait to life, use the Lasso tool and carefully draw around one eye. Hold down the shift key to add to your selection and draw around the other. Right-click inside your selection, choose Feather, and set Feather Radius to around 5 pixels.

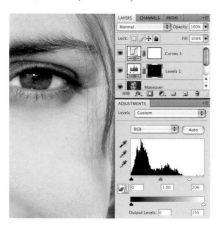

Step 7. Next, go to Layer>New Adjustment Layer>Levels, and drag the White Point Slider in to subtly brighten the whites of the eyes. Press Ctrl + D to deselect the eyes. You can also use this same technique for delicately whitening teeth.

Step 8. You may also want to selectively boost the color saturation of some of your subject's features, such as their lips. Reselect your Makeover layer and zoom in to a 50% view. Choose the Sponge tool from the toolbar (it's in with the Dodge and Burn tools), choose a soft brush around 100 pixels, and set Mode to Saturate and Flow to 10% so that you can build up the saturation slowly. Now paint over the lips to give the colors a boost. This is also a great way to lift the eye makeup colors.

Step 9. As always, finish off by sharpening your images. First create one layer by going to Layer>Flatten Image, then go to Unsharp Mask (Filter>Sharpen>Unsharp Mask). A good starting point is to set Amount to around 70%, Radius to 1.4 pixels, and then if you need to lessen the amount of sharpening, increase Threshold slightly. Be cautious of over-sharpening, as this can look unrealistic and introduce noise that will affect print quality. Also be aware of where and how your images will be printed, as what you see on screen can end up appearing softer on paper.

Black-and-White Conversion

Converting color images to black and white is a very quick and effective way of enhancing portraits and helping to draw immediate attention to your subjects. By desaturating your portraits you remove colorful distractions in background and foreground areas, which means the focus remains where you want it—on your subject. Monochrome conversions also bring out more detail and character lines in your subject's face, which is a great way of revealing more of their personality.

In this tutorial we look at how to make clinical black-and-white conversions in Photoshop. We also look at using Adjustment Layers and Layer Masks to selectively enhance backgrounds, show you how to selectively boost contrast with Curves and the Lasso tool, and demonstrate the correct way to sharpen images.

Before

After Image by Peter Travers

Step 1. For this tutorial we are using a portrait of an Italian man, taken on the Amalfi Coast in Italy. Subjects with interesting faces and defined features work well in black and white. Rather than shooting in monochrome, you will have more control and obtain better results if shooting in color and making the conversion in Photoshop afterward.

Step 2. Open your portrait in Photoshop and go to Layer>Duplicate Layer. It's good practice to always duplicate your original layer so that you can return to it if you make a mistake or are unhappy with your adjustments. Call the duplicate layer Mono, and go to Layer>New Adjustment Layer>Black & White.

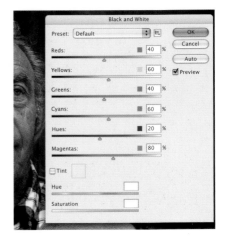

Step 3. In the Black & White dialog box you have control over the reds, yellows, greens, cyans, blues, and magentas, enabling you to adjust the gray tones of specific colors in your images. Dragging the Yellows and Reds sliders to the right is a good way to lighten skin tones. The presets can produce mixed results, but they're worth experimenting with. If you make a mistake, hold down the Alt key and click Reset.

Step 4. The straight black-and-white conversion is good to work from as a base, but it is a good idea to make finite enhancements with other tools. To darken your background and direct attention toward your subject go to Layer>New Adjustment Layer>Levels, and on the Levels dialog box move the Black Point slider in to around 40–50. At the bottom of the Layers Palette click on Add Mask.

Step 5. Now you can paint your subject back in using the Brush tool. Choose a soft brush around 600 pixels, set Mode to Normal and Opacity and Flow to around 40%. Press D to default your color palette and X to set your foreground color to black. Now hold down your mouse button and paint smoothly and accurately over your subject.

Step 6. There were a few light-colored distractions in the background so we used the Clone tool to remove them. Select the Mono layer on the Layers palette and zoom in to 100%. To use the Clone tool set a Brush size around 100–200 pixels with Mode on Normal and Opacity and Flow to 50%.

Step 7. Press the Alt key to sample the area you want to clone, and then click and brush over the distractions in your shot until the background is cleaner and consistently dark.

Step 8. To selectively boost the contrast of your subjects use the Lasso tool and draw a selection around their face. With the cursor inside your selection, right-click and choose Feather, and set Feather Radius to around 10 pixels. Go to Layer>New Adjustment Layer>Curves. Now create an S-curve, paying attention to the top part of the curve (which effects the highlights) to brighten the skin tones. Press Ctrl+D to deselect your subject, and go to Layer>Flatten Image to compress all of your layers.

Step 9. It's good practice to always sharpen your images at the end of your adjustments. How much or how little depends on your start image and the style of portrait. Sharpening this image has further boosted the contrast of lines and edges on the man's skin. Go to Filter>Sharpen>Unsharp Mask and set Amount to around 100% and radius to 1.2 pixels. To lessen the amount of sharpening increase Threshold slightly. Click OK and save your image.

HDR

Creating a HDR image is a great way of lifting your portraits and adding some extra punch. A true HDR image is the result of blending two or more exposures of exactly the same subject to create one image with a tonal range that would be unachievable from one single frame. HDR images reveal detail in the brightest highlights, in the midtones, and in the darkest shadows.

Although HDR is very popular with landscape and still life photographers, it's also a great way to transform your portraits. When photographing people you will need to use the single-frame method (see page 104), which ensures the three images will have identical framing. For this HDR tutorial you will need Adobe Photoshop CS3 or later.

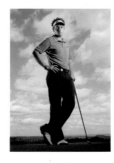
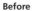

Before

After Image by James Cheadle

Step 1. You will first need to create three RAW files from your original using copy and paste. Create a folder for your chosen RAW files, right-click on the original file, and copy and paste it twice into the same folder. Rename your three RAW files HDR-Portrait1, HDR-Portrait2, and HDR-Portrait3.

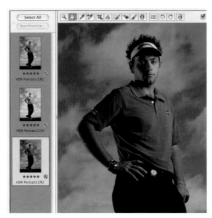

Step 2. Open the three RAW files in Photoshop's Camera Raw editor and process them individually. Create one correctly exposed file, one that's underexposed by 2/3 stop, and one that's overexposed by 2/3 stop. Do this using the Exposure slider (setting it to -70/+70). Select all three images and click the Done button.

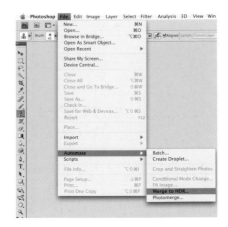

Step 3. To combine your three RAW files into one HDR image, launch Photoshop and go to File>Automate>Merge to HDR. Click the Browse button to locate the folder with the three processed files and add them to the selection to be merged. Tick the Attempt To Automatically Align Source Images box and click OK to begin the merging process.

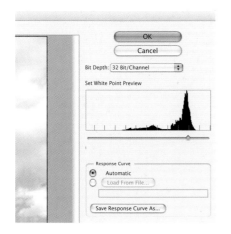

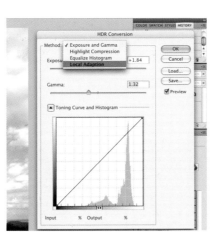

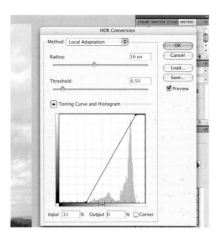

Step 4. Photoshop will now create a preview for you. At this point you have the opportunity to adjust the white point with the slider on the right. When setting the white point, aim to get as much information in both the shadows and highlights as possible. Click OK when you're happy with the image and Photoshop will create a 32-bit HDR TIFF file.

Step 5. You also have the option of adjusting the Exposure and Gamma levels using the sliders in the HDR Conversion dialog box. Every image will be different, so take some time to experiment with these controls. Adjustments to the histogram can also be made by clicking on the Method drop-down menu and selecting "Local Adaptation."

Step 6. Slide the white and black points at the top and bottom of the graph to ensure that both the shadows and highlights are just shy of clipping the side of the graph. Click OK.

Step 7. As Photoshop has created your 32-bit TIFF HDR image, you'll need to convert it to a 16-bit TIFF to apply your final adjustments (as most printers/screens can't handle 32-bit images). To do this, go to Image>Mode>16 Bits/Channel.

Step 8. You may notice that your HDR image looks a little flat, but it's routine to need to boost the saturation slightly to add some vibrancy to your finished image. Go to Image>Adjustments>Hue/Saturation and increase the saturation slider up to +10–20. You can save the HDR image as a TIFF or convert it to an 8-bit file (go to Image>Mode>8 Bits/Channel) to save it as a JPEG.

HDR software

There are other dedicated HDR programs available aside from Photoshop. Our favorite three alternatives, which all produce slightly different results, include Photomatix Pro, Easy HDR, and Dynamic Photo HDR.

Combining Images

Being able to combine two or more images successfully in Photoshop opens up unlimited possibilities, and in the modern age of digital photography it's becoming more common for images to be retouched in this way.

There can be various reasons for using this technique, from compensating for poor weather conditions, to budget restrictions for travel expenses on location shoots. In this tutorial we take an original portrait that was shot in dreary weather conditions and combine it with a dramatic background sky, which adds more color and extra impact.

Before

New background

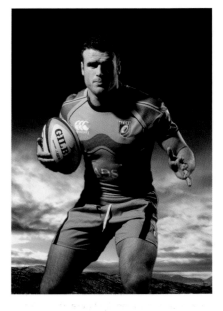

After Images by James Cheadle

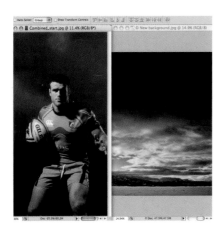

Step 1. First you will need your original portrait image and a new background image open in Photoshop. For this example, we're using two images—one of rugby player Jamie Roberts (see pages 58–59) shot on a dull winter's day in Wales, and another of a beautiful Norwegian sky.

Step 2. The first task is to select the subject, which will be dropped onto the new background image. Bring the portrait image to the front of the workspace, choose the Quick Selection tool on the left-hand toolbar, and set a Brush size of 250 pixels. This is a good size to use when selecting a rough outline of your subject.

Step 3. Steadily paint over your subject with the Quick Selection tool. In this case we wanted to select Jamie's entire body. This can be tricky, so take care and work slowly. Any mistakes can be rectified by clicking back one step on the History tab.

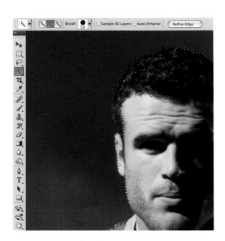

Step 4. We have a rough outline around the edge of the subject—to tidy up the selection reduce the Quick Selection tool brush size to around 50 pixels, zoom in to around 50%, and brush along the outline of your subject. If you go slightly over the outline of your subject hold down the Alt key and brush over your selection to subtract from it, or hold down the Shift key and brush over it to add to it.

Step 5. Now that your selection is complete you'll need to refine the edges. With the Quick Selection tool still live, right-click inside your selection and choose Refine Edge from the menu that appears on screen. To create a soft selection, set Radius to around 2 pixels and Feather to 3 pixels, and to smooth out any jagged edges increase Smooth a little. You can also Contract/Expand your selection to allow for any inaccuracies that may have been created.

Step 6. It's now time to combine the two images. Go to Edit>Copy, click on your new background image, and go to Edit>Paste. This automatically creates a new layer that will show up in the Layers Palette on the right-hand side.

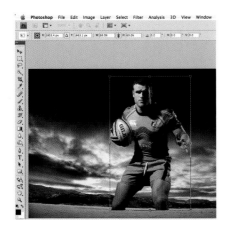

Step 7. The images have now successfully been combined, but the size of the subject looks unrealistic against the dramatic sky. To fix this, go to Edit>Transform>Scale, and resize your subject. Hold down the Shift key when resizing in order to maintain the subject's aspect ratio and avoid distortion. Once you've resized your subject and moved him into a good position, check the mark on the top bar to close the Transform tool.

Step 8. You may also need to make a few adjustments to each layer to ensure your two images blend naturally. To make the portrait match its new background we increased the color saturation by 10% (go to Image>Adjustments>Hue/Saturation) and cropped the image into a vertical composition using the Crop Tool. To complete the combination go to Layers>Flatten Image and then save your image as a hi-res JPEG or TIFF.

Photographer Contact Details

Ben Brain
www.benbrain.com

James Cheadle
www.jamescheadle.com

Lionel Deluy
www.lioneldeluy.com

Joe Giron
www.joegironphotography.com

Ed Godden
www.edgoddenphotography.com

Brett Harkness
www.brettharknessphotography.com

Daniel Kennedy
www.danielkennedy.com

Douglas Levere
www.douglaslevere.com

Daniel Milnor
www.milnorpictures.com

Adrian Myers
www.hmmm-uk.com

Bronia Stewart
www.broniastewart.com

Index

Index

Acknowledgments

Peter would like to mention:

My wife, Verity, and son, Harry
PhotoPlus magazine
Digital Camera magazine
PhotoRadar.com

James would like to mention:

My wife, Vicki, and children, Molly and Spencer
Viniculturists the world over

Peter and James would both like to thank:

Gingersnap Creative Management (www.gingersnap.co.uk)
Flow Images photo studio (www.flowimages.com)
Isheeta Mustafi and Diane Leyman at RotoVision